# CHRISTO PRINTS AND OBJECTS

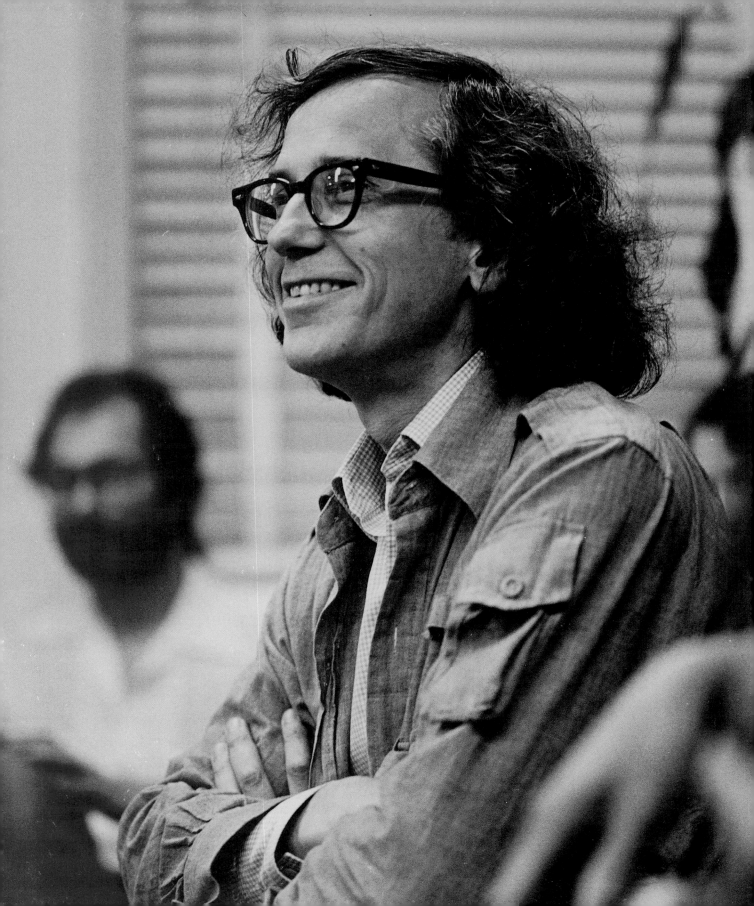

CHRISTO PRINTS AND OBJECTS, 1963–1987

A Catalogue Raisonné

Edited by Jörg Schellmann
and Joséphine Benecke
Introduction by Werner Spies

Edition Schellmann    Munich · New York
Abbeville Press  Publishers   New York

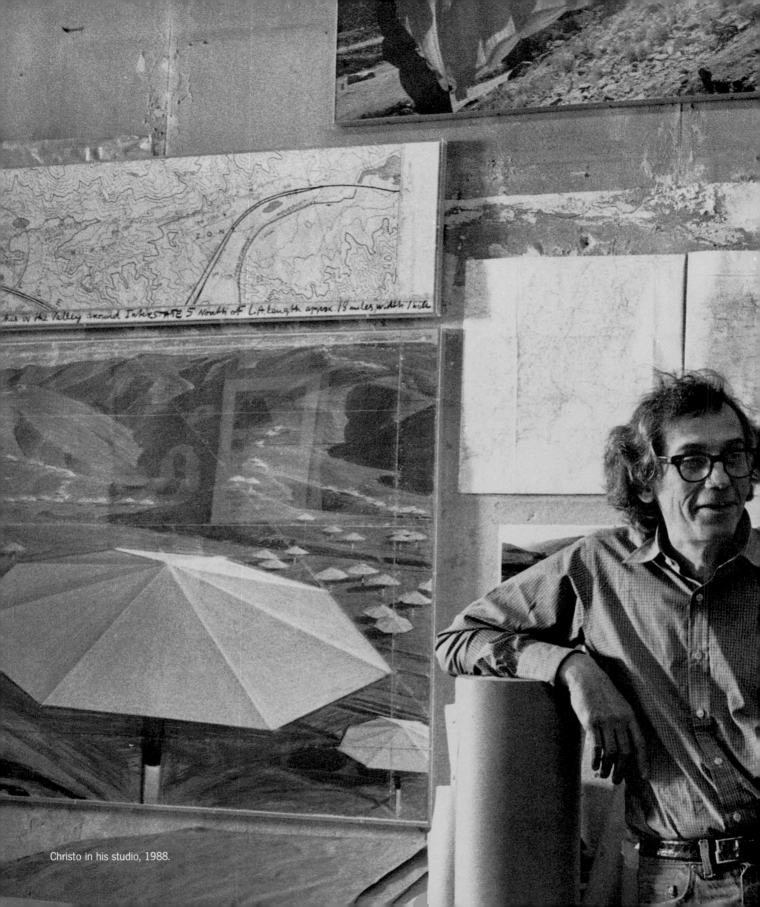

In the Valley around Interstate 5 North of LA Length approx. 18 miles, width Train

Christo in his studio, 1988.

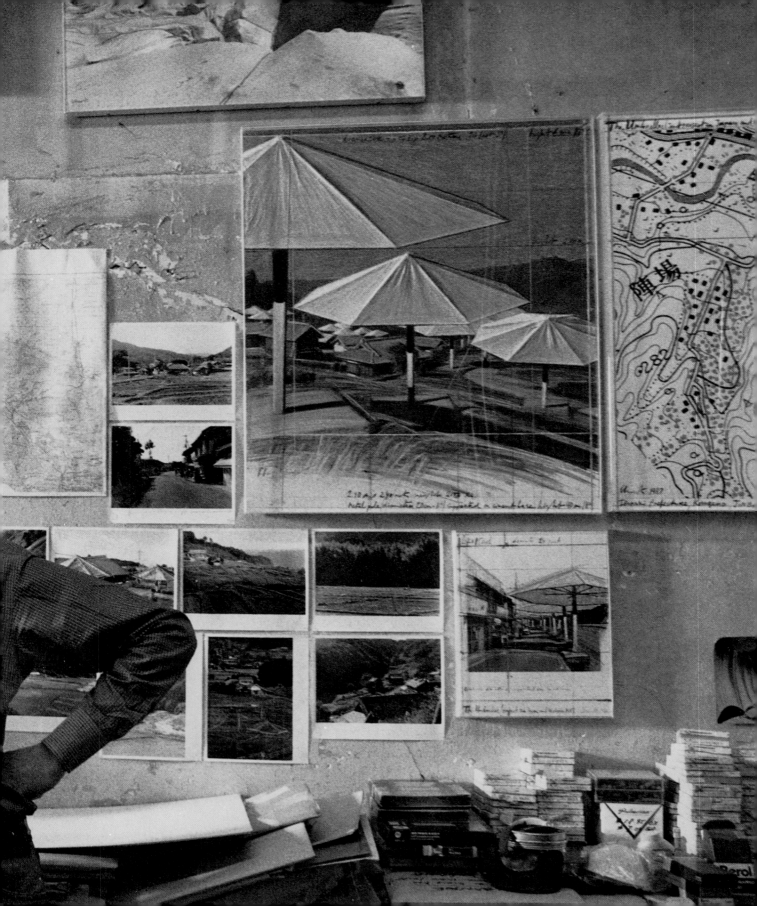

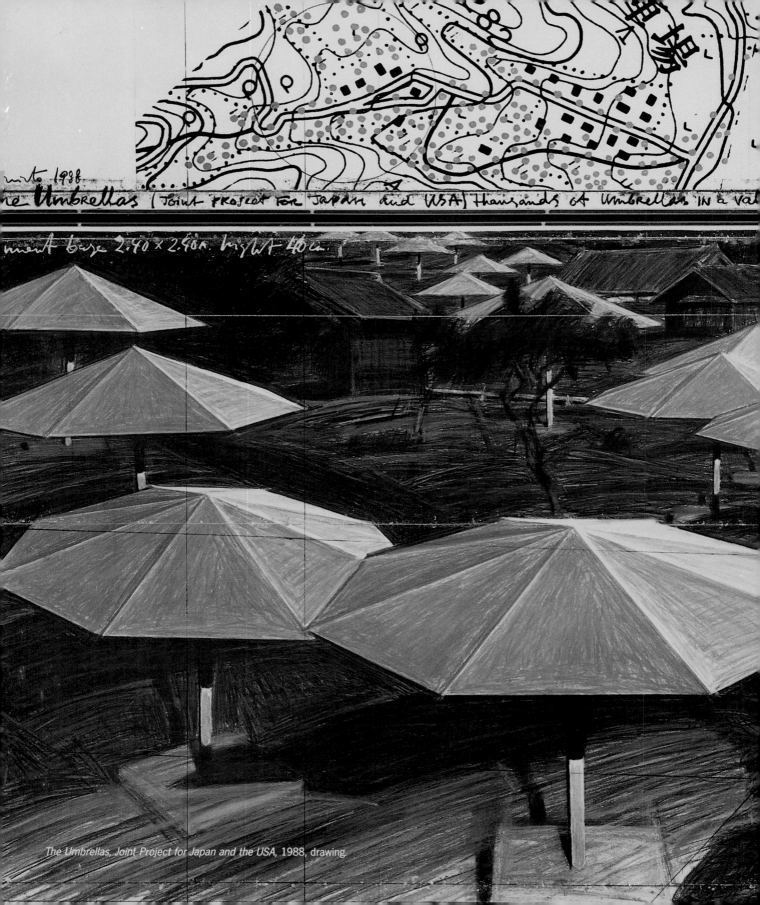

*The Umbrellas, Joint Project for Japan and the USA*, 1988, drawing.

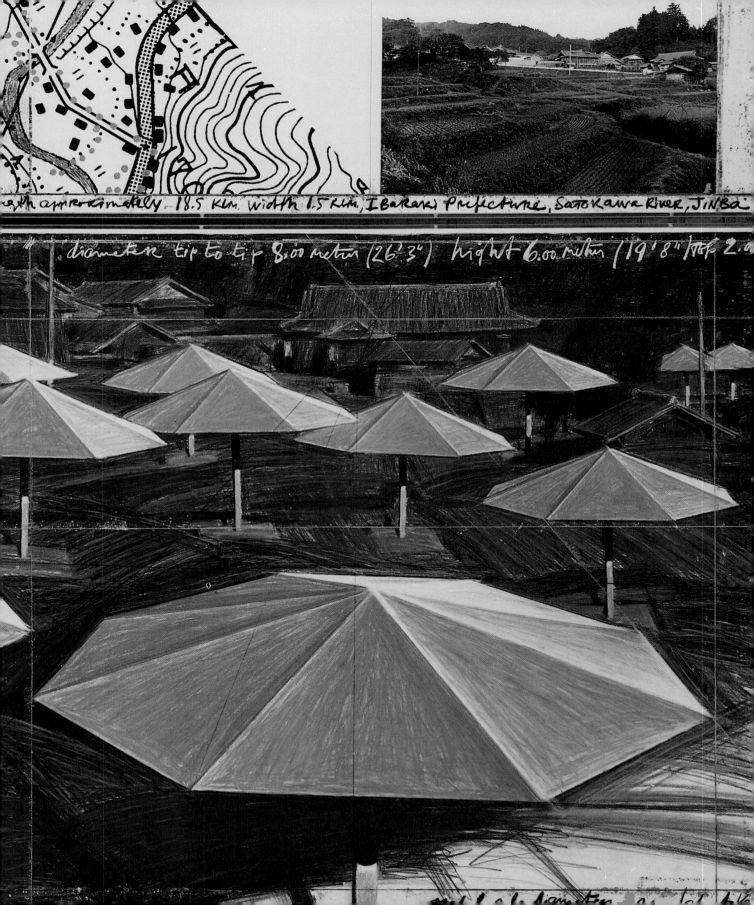

gth approximately 18.5 km. width 1.5 km, IBARAKI Prefecture, SATOKAWA RIVER, JINBA

diameter tip to tip 8.00 meter (26'3") hight 6.00 meter (19'8") Ref. 2.0

Front cover: *Wrapped Building, Project for 1 Times Square, New York,* 1985. See no. 128.

Back cover: *The Umbrellas, Project for Japan and Western USA,* 1987, collage (detail).

Library of Congress Cataloging in Publication Data
Christo, 1935 –
    Christo prints and objects, 1963–1987 /
introduction by Werner Spies; edited by
Jörg Schellmann and Joséphine Benecke.
    p.    cm.
    Includes index.
    ISBN 0-89659-796-2
    1. Christo, 1935 –  – – Catalogs.   I. Schellmann,
Jörg.   II. Benecke, Joséphine.   III. Title.
N7193. C5A4 1988
709' .2'4 – – dc19               87–27986 CIP

# Contents

# Introduction

This publication presents one integral aspect of Christo's oeuvre, the print and object editions. Extremely varied in both content and technique, this work evinces all of the approaches and procedures used in his large projects: wrapping, tying, covering — a silent obscuring of elements in the environment that temporarily deprives them of utility. Many images relate to the large projects with which he has made short-term, reversible interventions in cityscapes and landscapes. Some show completed projects, others record the artist's conceptions. All of them attest to the resistance that society has posed in one case or another, and they have their own intrinsic value as evidence of that opposition. Let us first note those projects that could not be realized: *Packed Building, Project for the Arc de Triomphe, Paris,* 1970; *Ten Million Oil Drums Wall, Project for the Suez Canal,* 1972; *Texas Mastaba, Project for 500,000 Stacked Oil Drums,* 1976; *Wrapped Bridge, Project for Le Pont Alexandre III, Paris,* 1977; and *Wrapped Monument to Cristóbal Colón, Project for Barcelona,* 1977. Christo dedicated an entire portfolio to *(Some) Not Realized Projects* in 1971. None of these, had they been carried out, would have essentially altered our image of the artist, however, for he has been able to realize the most important of his designs.

The objects and prints are enormously diverse, as are the techniques and media employed. Yet rather than reflecting a concern for graphic innovation, this diversity arises directly from the process of planning, developing, and realizing the projects. The activity of drawing and collage is a preparatory one with Christo. The designs he makes at this phase anticipate realization, representing imaginative projections of something that must first come to being. Yet they are not merely beautiful visions. On closer examination, we notice that these drawings, like architectural renderings or engineering sketches, contain much information about technical details. This sets them apart from utopian designs. In preparing a project Christo makes sketches and pastes in the actual materials he plans to employ. He makes frequent use of topographic photographs, adding elements of drawing and collage, using the photograph as a background for his draftsmanship.

Rapid, summary rendering ensures that the envisioned project will be stylistically adapted to its surroundings. The concern for the actual conditions of production, beyond the aesthetic effect of the result, gives rise to fascinating images that often, like encyclopedia illustrations, combine several sorts of information: an overall view, perspective renderings, and precise planning details. Looking at these sketches, we sense how closely allied are the act of drawing and the act of wrapping. The graphic elements — lines and shading — later become real ropes and material. And vice versa: the way Christo deploys his materials and ties them together transcends the mundane process of wrapping to become

three-dimensional drawing on a giant scale. As soon as a project is finished, Christo stops drawing. His sketches are always anticipations of something not yet visible, never renderings after the fact. The realized project is actually the definitve drawing. At this point Christo turns to other media. Photography, film, statistics, and reports are used to record the work and thus guarantee its survival, for after a few days or weeks it will have disappeared. From countless photos Christo carefully selects and authorizes those to be included in the documentary publications in which his work lives on. This applies also to the few photo editions he allows, which he considers part of his graphic oeuvre.

Every print and object has a function in Christo's work. None can be isolated; each participates in the triad of imagination, realization, and memory. Every sketch presses toward execution, and every finished project involves the pain of farewell, which in turn is captured in photographs. This is the irrevocable logic of Christo's strategy. It also determines the commercial necessity of his graphic art. Like the preliminary sketches and collages, the prints serve as the source of funds Christo needs to carry out the large projects. He has never accepted either public funding or private sponsorship. Freedom is his prime concern, and it is guaranteed by his sketches, collages, and editions.

Christo is one of the most popular artists in the world, and one whose popularity is easiest to bear. As striking and monumental as his works may be, they do not threaten our already crowded environment. They are really more in the nature of acts than works, for everything Christo has done over the years still exists in memory alone. His projects challenge our habitual perception with all the fleeting charm of an unrepeatable occurrence. Familiar landscapes, buildings we pass every day without seeing, suddenly become the focus of awareness; wherever Christo turns he succeeds in interrupting the predictability and pragmatism of the world. Anyone who has had the opportunity to experience one of his large projects, which gather like a storm and pass as quickly, can attest to this — and has probably become a permanent admirer. The change in perception that Christo causes amounts almost to a conversion. Each of his projects, by transforming mundaneness and challenging visual clichés, has helped to diminish the alienation of the viewer from his world.

Critics of Christo's projects tend to raise the irrelevant question of usefulness. They are oblivious of the rebellious force of the impractical, a vital corrective to the enervating world of unquestioning consensus. No one has expressed this better than Robert Musil. His words can be taken as a model for the mental exercise that Christo proposes anew with each project: "Normally, a herd of cattle means

nothing to us except grazing beef on the hoof. Or a picturesque motif against a background. Or something one simply overlooks. Cattle on mountain paths belong to the mountain paths; and one would realize what one was seeing only if suddenly in their place stood an electric station clock, or a tenement building."

The storms of protest that greeted Christo's earliest projects and that always gave way to wild enthusiasm are part of the mechanism of his success. The ritual and the procedure are by now familiar: wherever Christo appears and, with the help of a troop of assistants, undertakes his monumental interventions in people's accustomed lives, a bewildered and often furious uprising ensues. A pragmatic reckoning takes place. The culture of planned obsolescence demands permanence of art; Christo, out of a deep knowledge of his time, refuses to comply. Yet the initial fury soon subsides, making the work seem even more attractive and acceptable; from resistance and a lack of imaginative response the viewer moves to a feeling of sensual amazement. This process occurs time and again.

We spoke of Christo's acts. Well, to perform them requires a great deal of courage and a related quality known as initiative. In an era in which state and private groups timidly support the arts by asking the opinion of a hundred committees, who then apply tiny flourishes to an environment dominated by a hundred conflicting interests, Christo acts as his own patron. He does not accept a cent from the government or institutions. He finances all his projects through the sale of wrapped objects, collages, drawings, and graphic editions which announce projected works. All negotiations with the public or with partners — with the minister or the man in the street — Christo handles by himself, and he manages to get everyone involved. The artist's gentle power is indeed hard to resist.

In order to understand this fact we must take a glimpse at Christo's background and the development of his approach. His first known works were the purposely offhand wrappings and barricades produced during his early years in Paris. These brought him, in the early 1960s, into the orbit of the Nouveaux Réalistes. The critics initially tended to associate this early work with the typical period interest in surface textures and weather-beaten, painterly materials found by chance. In those days Christo produced the basic forms to which he has remained true ever since. His familiarity with Dada and Surrealism certainly played a considerable role. Nor should we overlook that aversion to materials, that negative fascination of surfeit, so compellingly described by Jean-Paul Sartre. This was the prevailing philosophy in Paris at that time, and something of its precarious balance between repulsion and

attraction shows in the heavy paint layers of Jean Fautrier, Antonio Tàpies, and Jean Dubuffet. Christo suddenly came on the scene, an unknown. Yet his delight in working on a gigantic scale, his art dependent on so many decisions and coincidences, ran counter to the Nouveau Réaliste approach. Christo himself has explained why: "My origins are very important to what I do. Fundamental, in a way. I owe a lot to my parents' home and to my education in Sofia." This is a decisive statement, considering that the education referred to culminated in Socialist Realism. Nevertheless, Christo feels that this environment gave him a comprehensive conception of art and introduced him to a broad range of definitions and implications. By the time he was seven, he had already begun drawing and painting. His parents provided him with a tutor, who instructed him in perspective and technique. "From childhood on, I had only one thought: to become an artist."

The young Christo steeped himself in art history and developed a precocious awareness of aesthetic problems, which he retained during his conventional training at the Sofia Academy. This is still apparent today. Art historical reflections are woven into the technical introductions he provides for his projects. Christo's knowledge of the architects of the French Revolution, for instance, is obviously large. This should not be overlooked when considering the first works he executed after coming to the West. Yet Christo seldom gives "artistic" commentary on his work. It is part of his tactics continually to deflect the aesthetic discourse so that it can be enlivened by transfusions of technical, political, or sociological information. In this sense his monumental projects are manifold riddles that confront a broad public, which is otherwise excluded from the arcane precincts of art.

From his mother, Christo says, he gained an early familiarity with Russian literature and art – with Mayakovski, Meyerhold, Tatlin, Goncharova, El Lissitzky. He knew of the gigantic festival decorations built in the Soviet Union between 1918 and 1921 to celebrate the anniversary of the October Revolution. Sergei Wassiliev, who was art director of the national film studio in Bulgaria for a few years after World War II, made a great impression on Christo. At that time in Sofia, the film studios sought the cooperation of artists, commissioning them to select shooting sites or to design décor. Propaganda art was a challenge to him, says Christo. It sparked his interest and willingness to discuss artistic projects with people of all kinds and to debate the most contradictory opinions. For this reason it is difficult for him, even today, to find his place in the Western art scene, which has primarily formalistic concerns, while he seeks an ongoing dialectic with powers that are indifferent or antagonistic to art. All of his projects are full of such confrontations. The wrapping of a stretch of coastline in Little Bay in Sydney; the giant

orange curtain he stretched across a canyon in Rifle, Colorado; the twenty-four-and-a-half-mile *Running Fence* in northern California; the *Surrounded Islands* in Miami's Biscayne Bay — all these projects during their short existence captured the interest of thousands, not only of collectors, critics, and so-called art lovers. And they always provoked a wide range of reactions, from logical argument to visionary pronouncement.

Of the many memories of Christo's youth in Bulgaria, one should be emphasized. While attending the Academy of Art in 1952–55 he regularly spent weekends with groups of students working in the country. Their job was to prettify the scenery along the route of the Orient Express through Bulgaria, to impress the travelers from capitalist countries. The students were sent to agricultural co-ops where they advised the farmers how to show off their tractors and other machinery to best advantage; they also showed them how to cover their haystacks with tarps in order to improve the rural landscape.

Perhaps as a result, in his early Paris years Christo took this cosmetic surgery designed to disguise the failings of a planned economy and turned it around. The chic packaging of capitalism, which can make even a low quality or useless product seem attractive and worth buying, probably had something to do with this. Christo's shrouded museums and monuments, and his draped, blind Store Fronts, so it was rashly stated, spoofed our faith in wrappings, in superficialities. However, unlike the world of advertising from which Pop art took its cues, Christo shifted the focus from packaging to contents. Warhol's Soup Cans, which ironically analyze the visual facets of a unit that is barely distinguishable from others like it, lie at the other extreme: they attest to a world consisting solely of externals. By contrast, in Christo's early works the outer skin and its glossy promises are transformed into a torn veil, behind which the viewer senses content of extreme variety: museums, landscapes, monuments, life, death.

To describe the monumentality to which Christo's works have accustomed us, only a comparison with twentieth-century architecture would suffice. His use of monumental scale is crucial, and not only in the pragmatic sense that it would be impossible for the artist personally to carry out his huge projects. As evident in the documentation collected and published during a project and the films used to record the construction process, the physical labor contributed by work teams plays an important part. His projects are stagings on a mass scale. Christo's role of producer and director is part of the work, not just a means to an end. This becomes obvious when we review the photographs, which he selects to

highlight the dramatic, pioneering character of the work. In sequence these photos reveal a process approaching culmination, resulting in a solution and a meaning. At first the work may seem hardly comprehensible, absurd, useless, but gradually its purpose becomes clearer. Christo draws the participants ever closer together until in the final phase of construction they are euphoric with a sense of victory. The results of these Herculean labors, strange configurations in some urban or geographical context, recall the Wonders of the World, which travel literature, with its emphasis on the "astonishing," has lauded since antiquity.

Everything that Christo has presented in the last few years has met with ever more excited, amazed, skeptical, and finally enthusiastic reactions, exhausting the critics' supply of superlatives. He basically works with two elements — monumental scale and transitoriness. Reviewing the books and catalogues that document these long-since vanished efforts, one is tempted to call Christo a producer of memories. One could speak of an aesthetic of transience, and indeed the artist himself has said: "I seek the involuntary beauty of the ephemeral." By this he means the memory of the creation of a satisfying, yet unrepeatable experience. What he leaves behind are not localizable monuments but reports and documents of a provisional audacity. Facets of the original work appear in these documents as if reflected in a mirror; and its destruction becomes the condition for the photographs, books, films, collages, drawings, and graphics that document it, lending them a compelling aura of something past and irretrievable.

Part of Christo's dramaturgy consists in creating suspense, including the possibility of disappointment this entails. The giant sausagelike *Air Package* he served up at Documenta 4 in Kassel, West Germany, was raised only after repeated attempts. The *Valley Curtain* in Rifle, Colorado — 1,313 feet wide and 365 feet high at its highest point — was torn apart by the wind as it was being hoisted in the autumn of 1971. But here, too, the second attempt succeeded. Mishaps occur so regularly, and resistance to Christo's projects is so certain, that a certain dose of anxiety seems planned. One could say that the success of his works initially overwhelms any aesthetic judgments. In this phase the realization of the project leaves no interval for judgment, since after a certain point one concentrates entirely on its successful completion. At the moment of highest suspense, just before success, all the participants heave a sigh of relief, feeling the sublimity of their own emotions and sensing release. The photos and films recording the excitement of such moments reveal a modification of artistic judgment, a shift from aesthetics to sheer amazement at Christo's technical and organizational skill. All of this makes his

undertakings popular and comprehensible in the broadest sense of the word. He has succeeded as no other has in preserving that individuality to which avant-garde art has accustomed us, and at the same time in circumscribing it, thanks to an objectively realizable criterion of success. There is something very seductive in watching Christo push his projects to the brink of impossibility. Instead of asking us to imagine the entire coast of Australia wrapped, he merely wrapped as much as he could, touching the borderline that separates realization from utopian wish and conceptual games.

Christo's most ambitious projects are so calculated that – like a technical experiment – they either succeed or fail. Once administrative impediments are taken care of – correspondence, contracts, surveys, the records of official hearings – comes the point when it is abruptly apparent whether the project will succeed or not. There can be no ironic Dadaist excuse of having intended to demonstrate failure or to spoof technology and its laws. Christo's monumental works show the opposite side of the heroic and gigantic, the hypertrophy of a moment, which the next moment has shrunk to nothing. The contracts that Christo signs compel him to remove the work within a certain time. Only when a project has vanished is it completed.

No one else has linked realization with destruction so closely, for these works do not exist as a concept alone – on this Christo insists. Plan, realization, and remembrance belong together. This separates Christo decisively from conceptual artists, who from an animosity toward the limitations of circum- stances either turn fully to the power of imagination or limit the physical aspect of their work so severely that without the help of a text it is formless and mute. Even though his plans seem so irrational and audacious, Christo remains fundamentally a realist. Recently he has conceived his works as though playing with utopia as if with fire. He has a predilection for working along the edge of the possible. He continually sets himself tasks whose outcome neither he nor the engineers with whom he works can foresee. The least imaginative people he has to deal with – initially – are the officials who must give their blessing to his projects.

However, without resistance there can be no Christo effect. All his projects meet with it. None of them are commissioned, nor does Christo allow himself to be bought off with alternative suggestions. In a sense all his projects begin again at zero. Every time, we hear the pros and cons, in which all the old arguments are recapitulated. Politicians, environmentalists, artists, and technicians are all drawn into the controversy that Christo's plans inevitably cause. All of this – resistance, argument, enthusiasm –

is part of the work. The way he gets heads of state, mayors, governors, chairmen of commissions, museum personnel, and critics involved is unprecedented and often disarmingly comic. It is all part of the dynamic of the project itself, for Christo has moved further into the public realm than most other artists. The possibilities of becoming engaged in work such as this are large, covering the entire spectrum of opinion found in public concerns. Often the discussions are protracted, yet each work that Christo realizes is a plea in the defense of the next. Forever moving from place to place, he always secures the best references and recommendations to take along. The most recent was written for him by a city where things were hardest for him for a long time: Paris. His wrapping of the Pont-Neuf, which cost Christo years of struggle, was an absolute success. Today everyone acknowledges this, even the politicians who finally let themselves be convinced that a sacred cow — and here we come back to Musil's *The Man without Qualities* — can indeed be more than "grazing beef on the hoof."

Werner Spies

*(Translated by John Gabriel)*

## Editors' Note

This catalogue raisonné contains the complete editions of prints, collages, and three-dimensional objects by Christo published from 1963 to the end of 1987.

It includes works published in limited editions that, with the exception of no. 11, are both signed and numbered. It does not include posters, books, or other publications.

Information was obtained from publishers when available and supplemented by consultation with the artist and the printers. This catalogue raisonné is as complete as possible at this date. We would like to acknowledge the pioneering efforts of Per Hovdenakk in *Christo Editions 1964–82*. In cases where our data differs from the text in that book, research indicates that our changes are correct.

Special thanks to Jeanne-Claude and Christo, who supported our work with patience and enthusiasm.

Joséphine Benecke        Jörg Schellmann

# Catalogue Raisonné

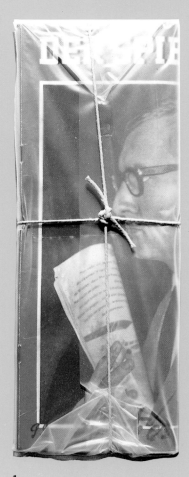

1

**1. *Der Spiegel* Magazine Empaqueté**

1963
*Der Spiegel* magazine folded and wrapped in transparent
polyethylene with twine and scotch tape
Size: 11¾ x 5⅛ x 1 in.
Edition: 130 copies, handmade by Christo
Publisher: Hans Möller, Düsseldorf

This edition was published as part of *Edition Original 1*, with
objects or prints by fifteen artists. Each number of the edition
contains a different issue of *Der Spiegel*.

Christo's first *Wrapped Magazines* were made in 1961.

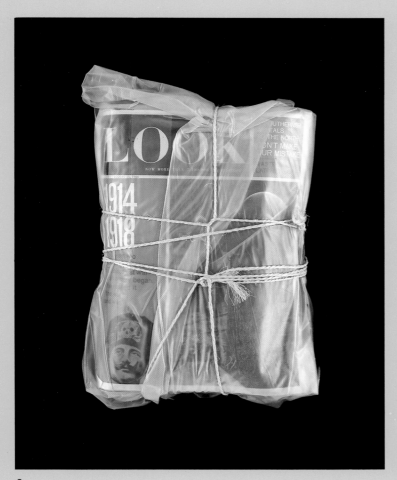

2

## 2. *Look* Magazine Empaqueté

1965
*Look* magazine wrapped in transparent polyethylene with
cord, on black wooden support
Size (of wooden support): 22 x 18⅛ x 1½ in.
Edition: 100 copies, handmade by Christo
(only 56 were made)
Publisher: MAT Edition/Galerie Der Spiegel, Cologne

Each number of this edition contains a different issue of *Look*,
wrapped in transparent polyethylene.
The work was published in the series *MAT Edition 2*, initiated
by Daniel Spoerri.

## 3. Wrapped Flower

1965
Plastic rose wrapped in transparent polyethylene with twine
Size: approx. 2½ x 18⅞ x 5½ in.
Edition: 10 copies, handmade by Christo
Publisher: George Maciunas

George Maciunas published several editions containing
works by artists who were somehow connected with Fluxus.
*Wrapped Flower* was never published in that context. It was
found in Maciunas's archives after his death in 1978.

See nos. 7, 8.

## 4. Wrapped Boxes

1966
Cardboard box wrapped in brown paper with twine
Size: 7⅞ x 7⅞ x 7⅞ in.
Edition: 100 copies, handmade by students from a
design class at Macalester College, St. Paul, Minnesota
Publisher: Minneapolis School of Art and Walker Art Center
Contemporary Arts Group, Minneapolis

Approximately twenty *Wrapped Boxes* were opened by the
recipients, who found this certificate inside:

> The package you destroyed was wrapped according to my
> instructions in a limited edition of 100 copies for members
> of Walker Art Center's Contemporary Arts Group. It was
> issued to commemorate my "14130 Cubic Feet Empaque-
> tage 1966" at the Minneapolis School of Art, a project
> co-sponsored by the Contemporary Arts Group.
>
> *Christo*
> This is no. ___ of 100
> 1966  Proof artist for Jeanne Claude

This edition was published on the occasion of Christo's
*42,390 Cubic Feet Empaquetage* at the Minneapolis School
of Art. (The measurement mentioned on the certificate is the
size originally planned for the *Air Package*.) The essence of
the project was the mailing of the boxes to members of the
Contemporary Arts Group. The boxes themselves are
ordinary ones and have no special value as art objects;
if they were opened by the recipients, they were destroyed
as works of art.

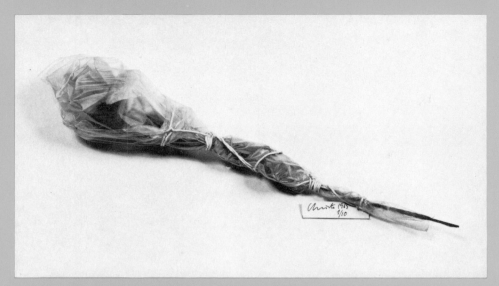

3

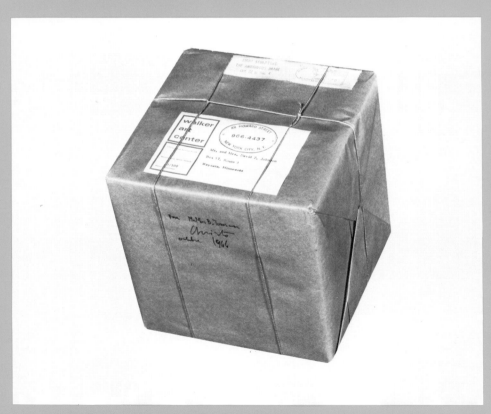

4

## 5. Corridor Store Front, Project

1967–68
Two-part screenprint with hinges, to be opened. Front
print die-cut, mounted on acetate; rear print mounted
on wooden support
Size: 28 x 22 in.
Edition: 75 copies
Printer: Hans-Peter Haas, Stuttgart (silkscreen);
Haarhaus, Cologne (offset)
Publisher: Documenta-Foundation, Kassel, and
Galerie Der Spiegel, Cologne

Christo donated this edition to the Documenta-Foundation.

See nos. 6, 16, 47–49, 93, 102, 104, 105.

*Corridor Store Front,* 1967–68, Documenta 4, Kassel.

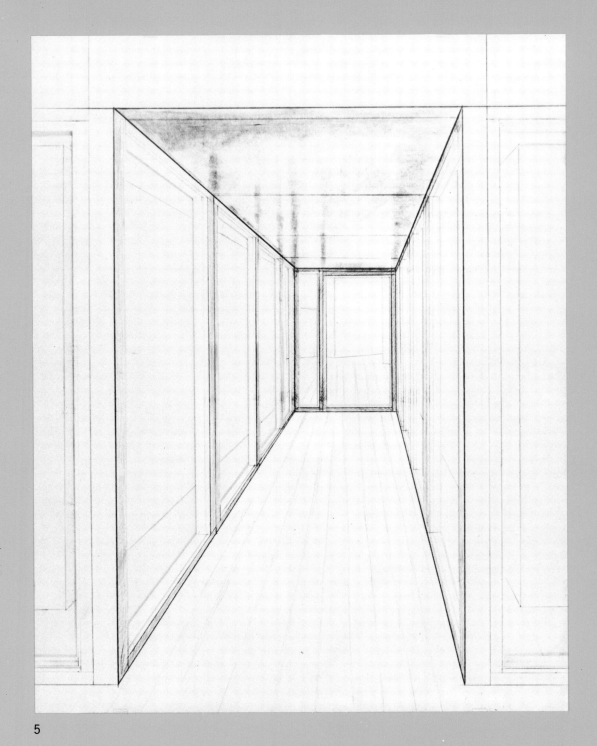

5

### 6. Corridor Store Front, Project

1968
Two-part screenprint with hinges, to be opened. Front print die-cut, mounted on acetate; rear print mounted on cardboard
Size: 27½ x 21⅝ in.
Edition: 100 copies (+ 25 A.P.)
Printer: Hans-Peter Haas, Stuttgart
Publisher: Verlag Gerd Hatje, Stuttgart

Christo donated this edition to help fund the publication of the book *Christo* by Lawrence Alloway, published by Verlag Gerd Hatje, Stuttgart.

See nos. 5, 16, 47–49, 93, 102, 104, 105.

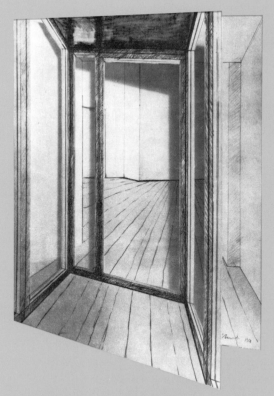

6   Open

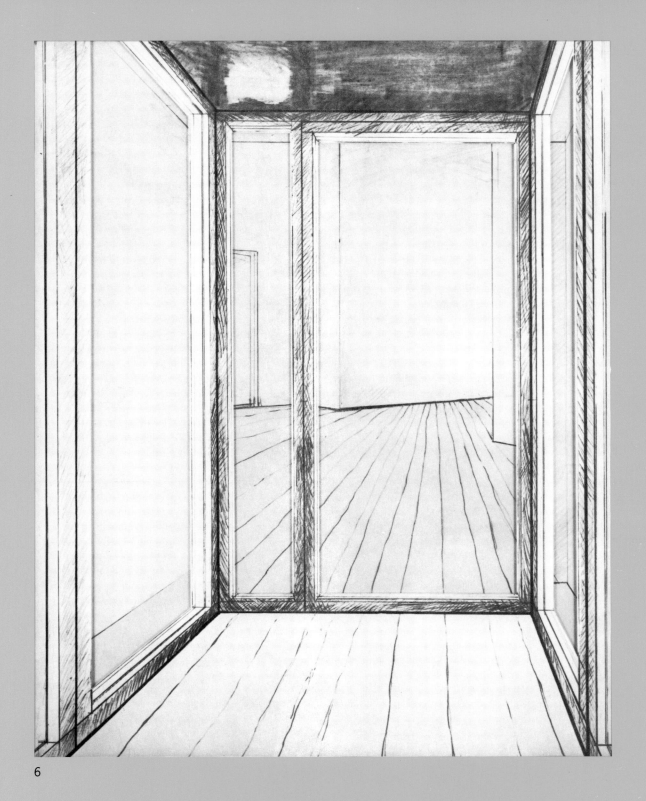

6

## 7. Wrapped Roses

1968
Three plastic roses wrapped in transparent polyethylene
with twine
Size: approx. 4 x 22 x 5 in.
Edition: 75 copies, handmade by Christo
Publisher: Institute of Contemporary Art, University of
Pennsylvania, Philadelphia

This edition was published on the occasion of Christo's
exhibition at the Institute of Contemporary Art, Philadelphia,
to help raise funds to cover the expenses of the temporary
installation there of *1,240 Oil Barrels Mastaba*.

See nos. 3, 8.

## 8. Wrapped Roses

1968
Plastic roses wrapped in transparent polyethylene with twine
Size: approx. 3½ x 25½ x 6¼ in.
Edition: 75 copies, handmade by Christo
(probably only 45 were made)
Publisher: Richard Feigen Graphics, New York

See nos. 3, 7.

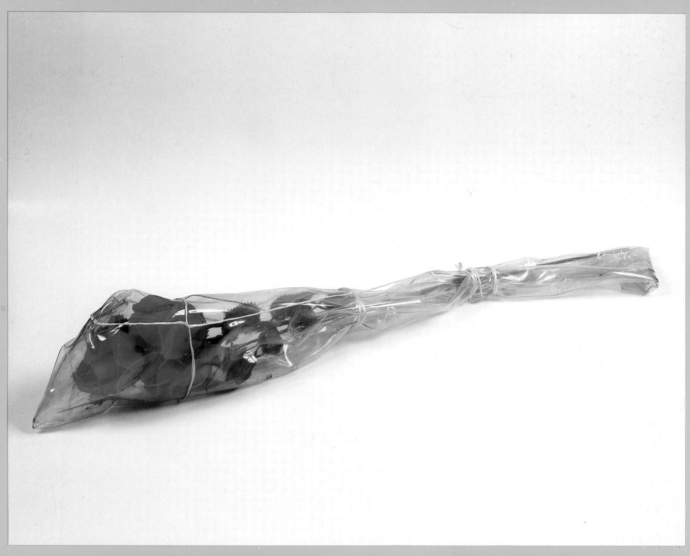

7, 8

## 9. 5,600 Cubic Meter Package, Kassel, 1968

1968
Photograph (b/w)
Size: 23⅝ x 19¾ in.
Edition: 50 copies
Photographer: Klaus Baum
Publisher: Christo

This photograph, showing the *5,600 Cubic Meter Package* being erected at Documenta 4 in Kassel, was published to raise money for the project. Part of the edition was sold through the Documenta-Foundation.

The *Air Package* was placed for two months in Karlsaue Park, Kassel, in front of the Orangerie.
Height: 280 feet
Diameter: 33 feet
Weight: 14,000 pounds
Skin: 22,000 square feet of Trevira fabric coated with PVC
Ropes: 12,000 feet of one-inch diameter polyethylene
6 concrete foundations, in which supporting cables were anchored
Erected between 4:00 am and 2:00 pm on August 3, 1968, using five truck-cranes
The project was financed by Christo.

See nos. 10–12, 15, 131.

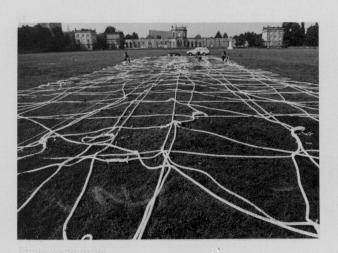

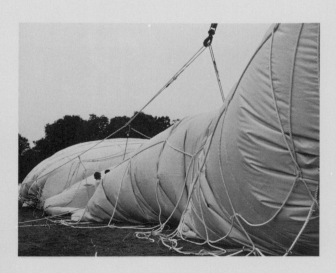

The *Air Package* in process of installation.

27/50 Christo
1968

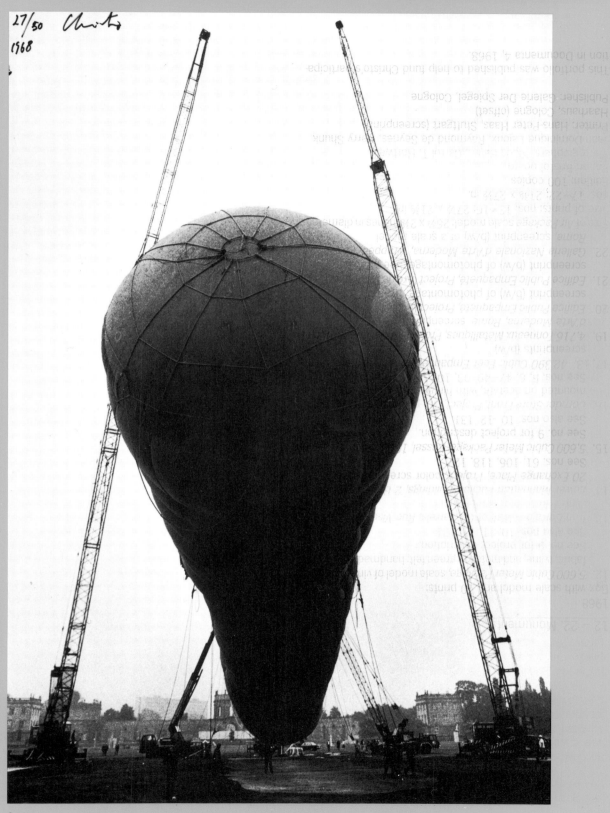

9

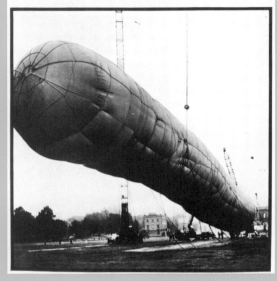

die grösste flexible hülle der welt    »christoprojekt« documenta 4
herstellung:    wülfing & hauck    3504 oberkaufungen / kassel

10

### 10. 5,600 Cubic Meter Package, Kassel, 1968

1968
Screenprint on Mylar (some copies on paper)
Size: 53⅜ x 33⅝ in.
Edition: 150 copies: approx. 50 black on white;
approx. 50 black on red; approx. 50 black on silver
Photographer: Klaus Baum
Printer: Julius Kress, Kassel
Publisher: Wülfing & Hauck, Kassel

Christo signed this edition to thank Mr. Wülfing and Mr. Hauck
for having accepted a postdated check for the Trevira fabric
envelope that Christo ordered from them for the *Air Package*,
even though they knew there were no funds in the bank
account at the time of the purchase order.

See no. 9 for project description.
See also nos. 11, 12, 15, 131.

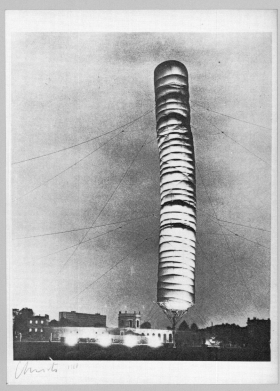

11

## 11. 5,600 Cubic Meter Package, Kassel, 1968

1968
Color offset print
Size: 22¾ x 17⅞ in.
Edition: 500 copies: only 200 signed, all unnumbered
Paper: 120 g offset
Photographer: Klaus Baum
Printer: Gebr. Zahnwetter, Kassel-Sandershausen
Publisher: Griffelkunst, Hamburg

See no. 9 for project description.
See also nos. 10, 12, 15, 131.

## 12 – 22. Monuments

1968
Box with scale model and 10 prints:

12. *5,600 Cubic Meter Package,* scale model of vinyl-coated fabric, twine, and metal on green felt; handmade by Christo
   See no. 9 for project description.
   See also nos. 10, 11, 15, 131.

13. *Iron Curtain – Wall of Oil Barrels, Rue Visconti, Paris, June 1962,* color screenprint

14. *Lower Manhattan Packed Buildings, 2 Broadway and 20 Exchange Place, Project,* color screenprint
   See nos. 61, 106, 118, 127.

15. *5,600 Cubic Meter Package, Kassel, 1968,* color screenprint
   See no. 9 for project description.
   See also nos. 10–12, 131.

16. *Corridor Store Front, Project,* two-part screenprint (b/w) mounted on acetate, with hinges, to be opened
   See nos. 5, 6, 47–49, 93, 102, 104, 105.

17, 18. *42,390 Cubic Feet Empaquetage, Minneapolis, 1966,* screenprints (b/w)

19. *4,716 Tonneaux Métalliques, Project for Galleria Nazionale d'Arte Moderna, Rome,* screenprint (b/w)

20. *Edifice Public Empaqueté, Project* (Ecole Militaire, Paris), screenprint (b/w) of photomontage. See no. 31.

21. *Edifice Public Empaqueté, Project* (Arc de Triomphe, Paris), screenprint (b/w) of photomontage. See no. 32.

22. *Galleria Nazionale d'Arte Moderna, Wrapped, Project for Rome,* screenprint (b/w) of a scale model

Size of *Air Package* scale model: 26¾ x 2⅜ inches in diameter
Size of prints: nos. 13–16: 27½ x 21⅜ in.;
nos. 17–22: 21⅜ x 27½ in.
Edition: 100 copies
Paper: Bristol board
Photographers: Klaus Baum, Carrol T. Hartwell,
Jean-Dominique Lajoux, Raymond de Seynes, Harry Shunk
Printer: Hans-Peter Haas, Stuttgart (screenprint);
Haarhaus, Cologne (offset)
Publisher: Galerie Der Spiegel, Cologne

This portfolio was published to help fund Christo's participation in Documenta 4, 1968.

12 – 22
Portfolio box

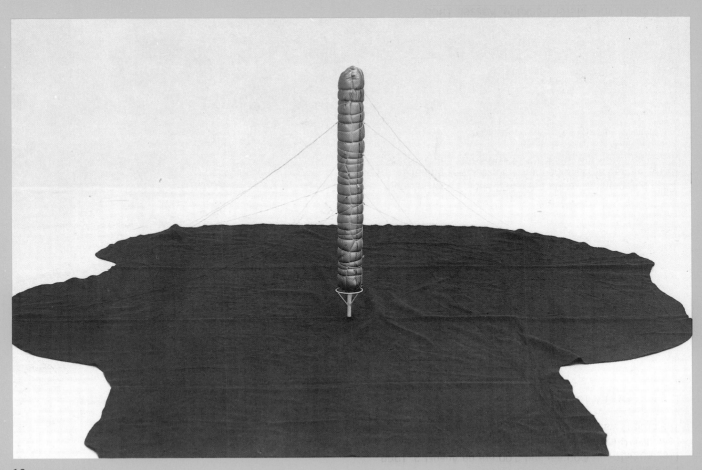

12

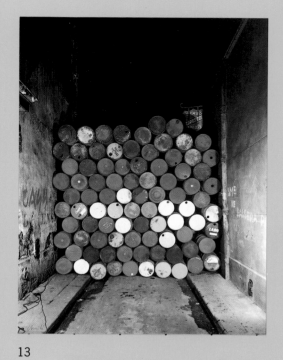

13

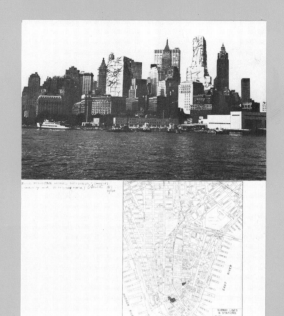

14

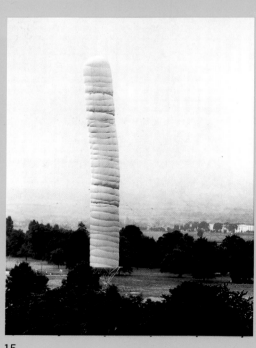

15

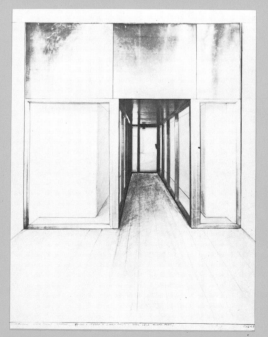

16

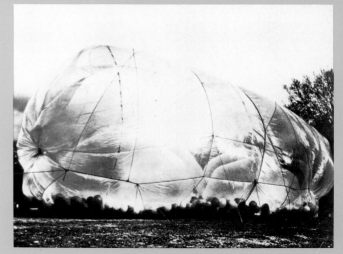

17

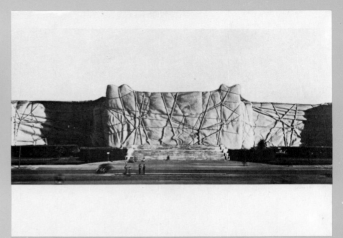

18

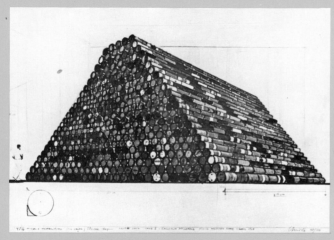

19

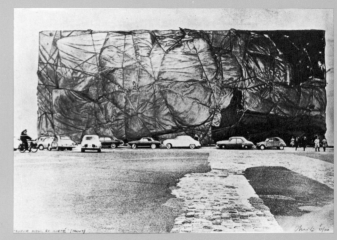

20

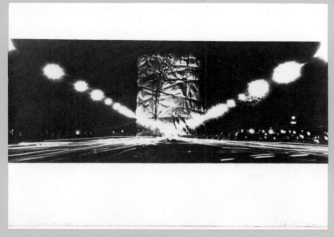

21

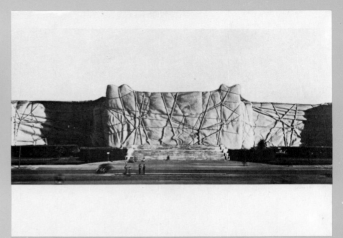

22

## 23. Packed Kunsthalle Bern, 1968

1968
Offset print
Size: 38¾ x 27¼ in.
Edition: 200 copies
Paper: White board
Photographer: Frank Donell
Publisher: Kunsthalle Bern

Christo donated this edition to the Kunsthalle Bern for its
fiftieth anniversary.

See nos. 43–46 for project description.
See also no. 24.

## 24. Packed Kunsthalle Bern, 1968

1969
Screenprint on gold or silver foil, mounted on cardboard
Size: 13¾ x 19⅝ in. (gold); 9⅞ x 14⅛ in. (silver)
Edition: 54 copies
Photographer: Thomas Cugini
Printer: Druckerei Ebner, Aglasterhausen
Publisher: Edition Staeck, Heidelberg

Christo donated this edition to Intermedia 1969, Heidelberg.

See nos. 43–46 for project description.
See also no. 23.

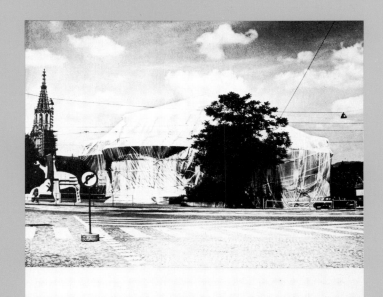

50 Jahre
Kunsthalle
Bern

23

24

## 25. Wrapped Painting

1969
Offset print, printed on both sides, die-cut
Size: 32¼ x 23⅝ in.
Edition: 100 copies (+ some A.P.)
Paper: White board
Photographer: Harry Shunk
Printer: Johnson Printing, Minneapolis
Publisher: Contemporary Art Lithographers, Minneapolis

This print was published on the occasion of Christo's wrapping the Museum of Contemporary Art, Chicago (see no. 50). He tried out various materials for the wrapping of the building by wrapping several paintings with different fabrics; a photograph of one of those paintings was used for this edition. Both sides are reproduced on the print.
The same image was used as a poster for the exhibition.

25   Verso

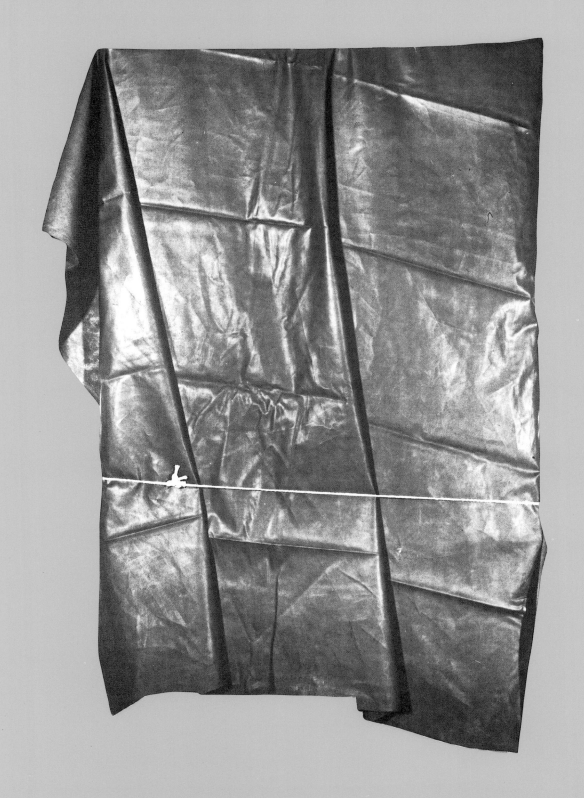

25

## 26. 56 Stacked Barrels

1969
Color screenprint
Size: 27½ x 19¾ in.
Edition: 60 copies (+ 5 A.P.)
Paper: 150 g
Photographer: Pieter Mol, Breda
Printer: Rolf Weeber, Breda
Publisher: Galerie Seriaal, Amsterdam

The print is based on a photograph of the *56 Stacked Barrels*,
made in 1966 for the Dutch collectors Mia and Martin Visser,
who later donated the structure to the Rijksmuseum
Kröller-Müller, Otterlo.

*Barrel Tower,* Paris, 1961.

1969
Screenprint on gold or silver foil, mounted on cardboard
Size: 13¾ x 19⅝ in. (gold); 9⅞ x 14⅛ in. (silver)
Edition: 54 copies
Photographer: Thomas Cugini
Printer: Druckerei Ebner, Aglasterhausen
Publisher: Edition Staeck, Heidelberg

Christo donated this edition to Intermedia 1969, Heidelberg.

See nos. 43–46 for project description.
See also no. 23.

## 23. Packed Kunsthalle Bern, 1968

1968
Offset print
Size: 39¾ x 27¼ in.
Edition: 200 copies
Paper: White board
Photographer: Frank Donell
Publisher: Kunsthalle Bern

Christo donated this edition to the
fiftieth anniversary.

See nos. 43–46 for project descri
See also no. 24.

## 24. Packed Kunsthalle Bern, 1968

1969
Screenprint on gold or silver foil, mounted on cardboard
Size: 13¾ x 19⅝ in. (gold); 9⅞ x 14⅛ in. (silver)
Edition: 54 copies
Photographer: Thomas Cugini
Printer: Druckerei Ebner, Aglasterhausen
Publisher: Edition Staeck, Heidelberg

Christo donated this edition to Intermedia 1969, Heidelberg.

## 27. Wrapped Staircase

1969
Offset print (b/w), printed on both sides
Size: 22⅞ x 15¼ in.
Edition: 110 copies (+ 10 A.P.)
Paper: 300 g offset
Photographer: Harry Gruyaert
Printer: Veereman, Dreuve-Antwerp
Publisher: Wide White Space Gallery, Antwerp

This print, which was made for Christo's exhibition in the Wide White Space Gallery, shows the wrapping of the gallery's Flemish staircase. The entire inside of the gallery was wrapped with tarpaulin. The verso of the print shows the stairway as it normally appears.

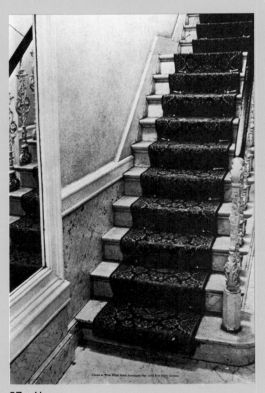

27   Verso

44

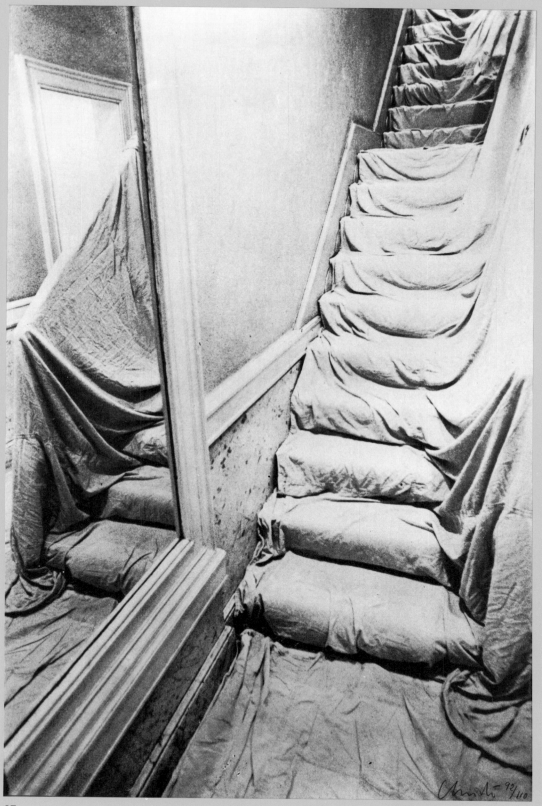

27

45

## 28. America House Wrapped, Heidelberg, 1969

1969
Screenprint (b/w) with collage of polyethylene
Size: 35½ x 24⅝ in.
Edition: 200 copies (+ some A.P.)
Paper: Schoeller-Hammer
Photographer: Jochen Goetze
Printer: Druckerei Ebner, Aglasterhausen
Publisher: Edition Staeck, Heidelberg

Christo wrapped the America House, Heidelberg, with
polyethylene, a piece of which was attached to the print.
He donated this edition to Intermedia 1969, Heidelberg.

## 29. Cologne Cathedral, Packed

1969–70
Souvenir model of Cologne Cathedral inside a transparent
plastic bag
Size: approx. 14¼ x 3¾ x 1¼ in.
Edition: 40 copies (only about 20 were made)
The edition was fabricated by Klaus Staeck;
Christo only signed the labels.
Publisher: Edition Staeck, Heidelberg

This edition was published as a donation to Intermedia 1969,
Heidelberg.

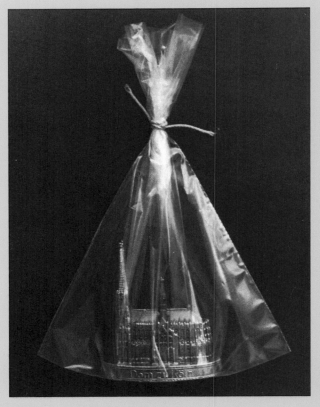

29

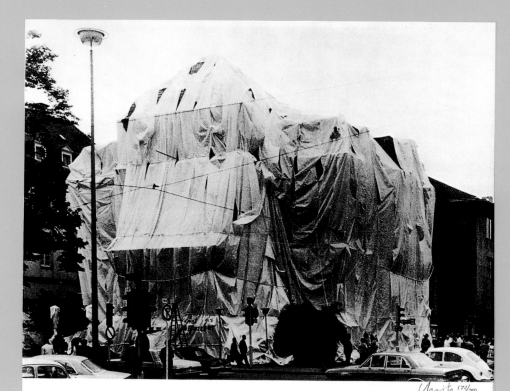

AMERICA HOUSE WRAPPED   Christo 1969

28

## 30. Wrapped Coast, Little Bay, Australia, One Million Square Feet, 1969

1969
Offset print (b/w)
Size: 38¾ x 27 in.
Edition: 50 copies
Paper: 150 g offset
Photographer: Harry Shunk
Printer: Haarhaus, Cologne
Publisher: Galerie Der Spiegel, Cologne

This print was made for an exhibition of *Wrapped Coast* documentation at Galerie Der Spiegel, Cologne.
The same print, with type, was used as poster for the exhibition.

See no. 76 for project description.

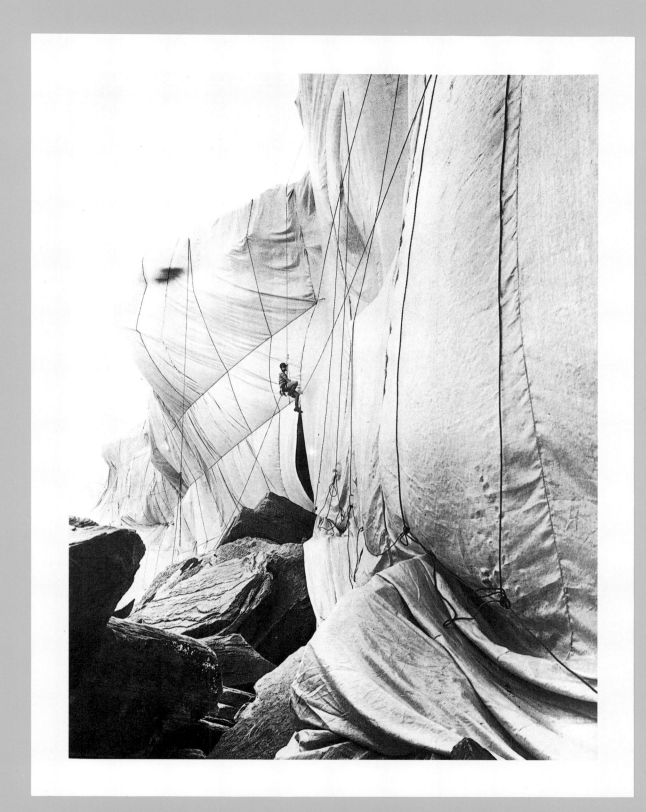

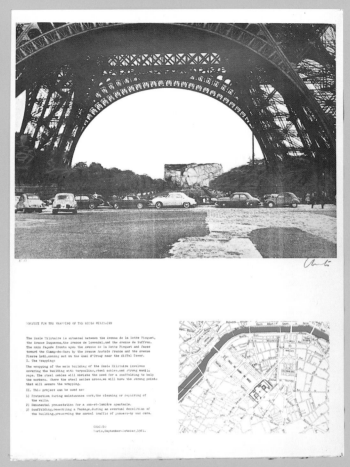

31

## 31. Packed Building,
## Project for the Ecole Militaire, Paris

1970
Color lithograph
Size: 25⅝ x 19¾ in.
Edition: 300 copies (+ X A.P.)
Paper: Arches
Photographer: Harry Shunk
Printer: Atelier Clot, Bramsen et Georges, Paris
Publisher: Jacques Putman, Paris

This lithograph is a reproduction of a photomontage.

The projects for the Ecole Militaire and the Arc de Triomphe (see no. 32) were Christo's first projects for the wrapping of public buildings, but were never realized.

See no. 20.

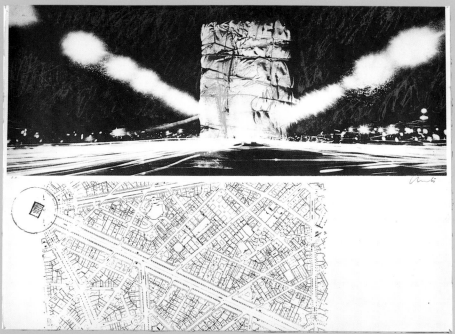

32

32. Packed Building,
Project for the Arc de Triomphe, Paris

1970
Color lithograph
Size: 19¾ x 25⅝ in.
Edition: 300 copies (+ X A.P.)
Paper: Arches
Photographer: Harry Shunk
Printer: Atelier Clot, Bramsen et Georges, Paris
Publisher: Jacques Putman, Paris

This lithograph is a reproduction of a photomontage.

See no. 21.

## 33. Wrapped Tree, Project

1970
Color screenprint
Size: 24⅜ x 32¾ in.
Edition: 150 copies (+ 15 A.P.)
Paper: Bristol board
Photographer: Harry Shunk
Printer: Hans-Peter Haas, Stuttgart
Publisher: Galerie Der Spiegel, Cologne

This print was included in the portfolio *Spiegel 70,* published for the twenty-fifth anniversary of Galerie Der Spiegel.

The first life-size *Wrapped Tree* was made in Holland in 1966 as part of Christo's exhibition at the Stedelijk Van Abbe-museum, Eindhoven.

See no. 101.

## 34. Monschau Project

1971
"Do-it-Yourself Catalogue" for the Monschau project.
Cardboard box containing signed postal sticker, ball of twine, plastic souvenir model of the castle of Monschau, 2 photographs of Christo's preparatory drawings, 2 photographs of the wrapped box, a piece of gray polypropylene fabric used for the wrapping, and 19 pages of information about the project
Size of box: 6½ x 9 x 6½ in.
Edition: 150 copies
Publisher: Kunstkreis Monschau

The catalogue, edited by Willi Bongard, could be transformed by the buyer into an art object signed by Christo.

The wrapping of Burg Monschau, West Germany, took place on September 29, 1971, while Christo was in Rifle, Colorado, working on *Valley Curtain.* Christo authorized his friend Willi Bongard to supervise the wrapping of the castle in Monschau.

33

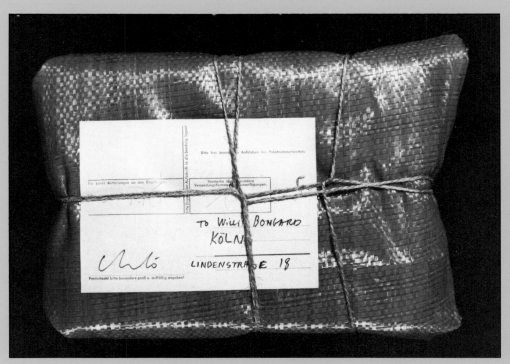

34

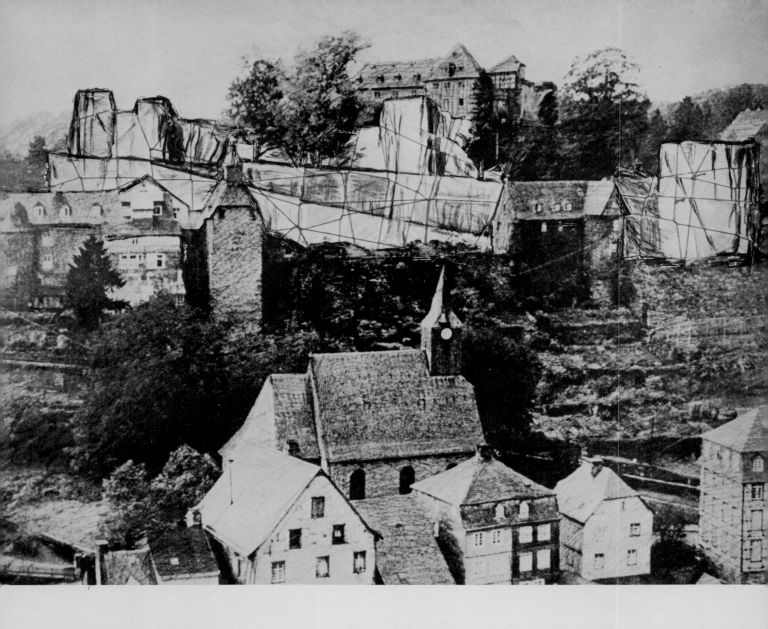

*Wrapped Schloss, Project for Monschau,* 1971, collage (detail).

54

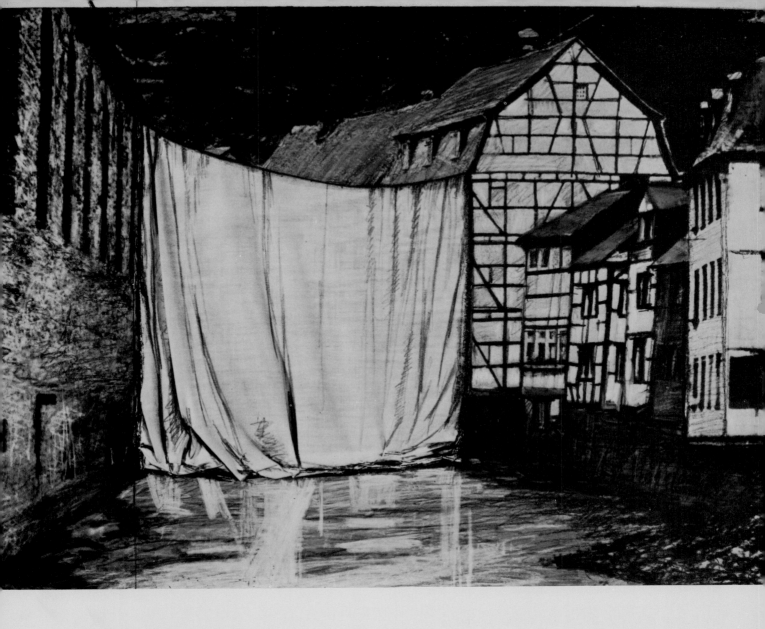

*Curtains for Monschau, Rur River, Project for September 1971 in Monschau,* 1970, collage (detail).

## 35 – 39. (Some) Not Realized Projects

1971
Portfolio with 5 prints:
35. *Whitney Museum of American Art, Packed, Project for New York,* color lithograph with collage of fabric, twine, thread, staples, and transparent polyethylene
36. *The Museum of Modern Art, Wrapped, Project for New York,* color lithograph with collage of photograph and city map
37. *The Museum of Modern Art, Wrapped, Project for New York,* color lithograph of photomontage
38. *Allied Chemical Tower, Packed, Project for 1 Times Square, New York,* color lithograph
    See no. 128.
39. *Allied Chemical Tower, Packed, Project for 1 Times Square, New York,* color lithograph of photomontage
    See no. 128.
Size: 28 x 22 in.
Edition: 100 copies (+ X Roman numerals + 10 A.P.)
Paper: Arjomari
Photographers: Harry Shunk, Ferdinand Boesch
Printer and publisher: Landfall Press, Chicago

The wrapping of the Whitney Museum of American Art, New York, was suggested for the museum's Sculpture Biennial in 1968, but there was little enthusiasm for it and the project was never realized.

The proposal to wrap the Museum of Modern Art, New York, was launched in 1968, when the museum showed the exhibition *Dada, Surrealism and Their Heritage.* The idea was to wrap the museum and to build a mastaba of barrels in the main hall and a wall of oil drums outside the museum across 53rd Street. At the time, there were a number of street demonstrations in New York, and the city authorities and insurance companies would not grant permission for the project, fearing that it would lead to new demonstrations. The scale model used to make the photomontage in print no. 37 of this portfolio is in the collection of the Museum of Modern Art.

The building at 1 Times Square was of great interest to Christo. He approached the various owners of the building several times for permission to do the wrapping, but without success.

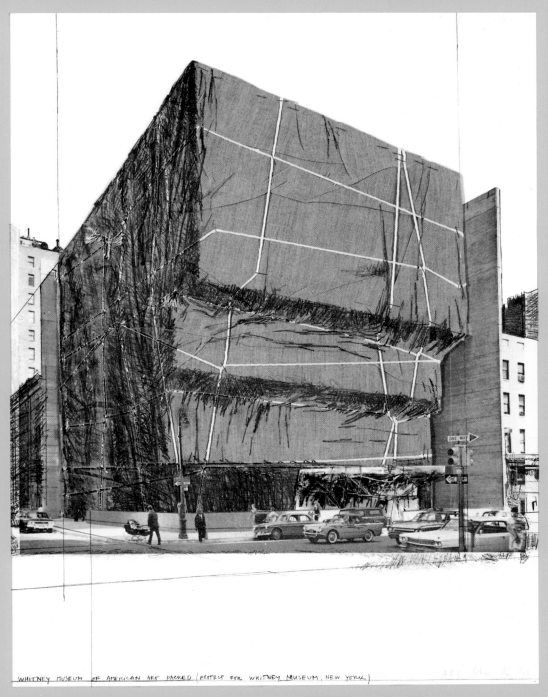

WHITNEY MUSEUM OF AMERICAN ART PACKED (PROJECT FOR WHITNEY MUSEUM, NEW YORK)

35

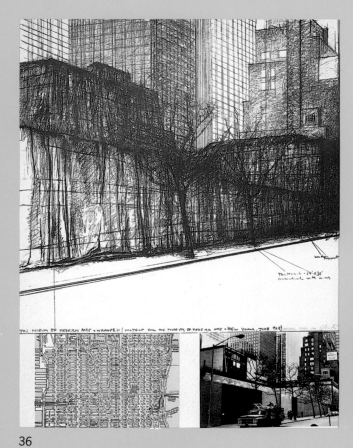

36

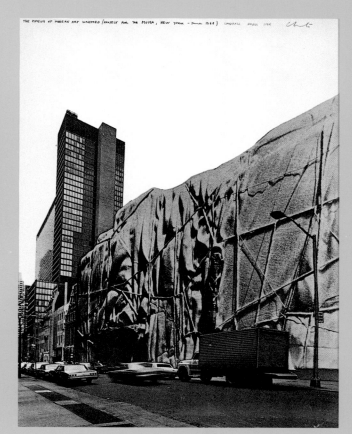

37

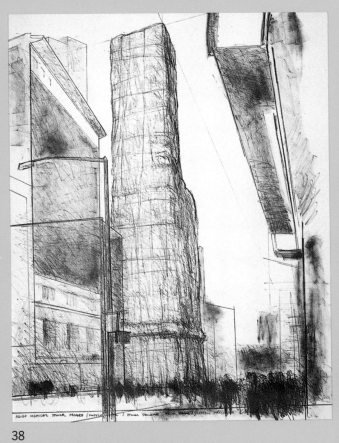

38

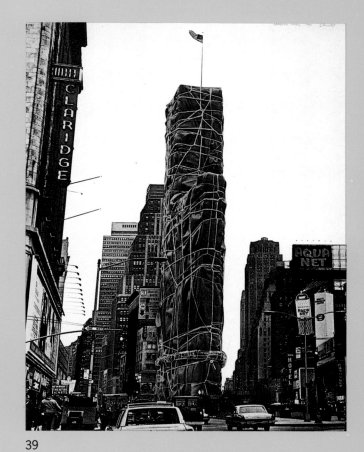

39

## 40 – 42. Wrapped Monument to Leonardo, Project for Piazza della Scala, Milan

1971
40. Collotype (b/w) with collage of fabric, red thread, and
    staples
41. Color lithograph and collotype
42. Color collotype
Size: 29⅜ x 21⅞ in.
Edition: Two sets of two prints each:
nos. 40 and 42, 99 copies each; nos. 41 and 42, 999 copies each
Paper: Rives Couronne
Photographers: Shunk – Kender
Printer: Matthieu AG, Zurich
Publisher: Edition 999, Zurich

These prints were published to raise money for *Valley Curtain*.

The wrapping of the monument to Leonardo da Vinci took place in 1970. Two days after the wrapping was completed, the monument was set on fire during a political demonstration. The project was part of a large presentation of Nouveau Réalisme, organized by the city of Milan. During this exhibition, Christo also wrapped the monument to Vittorio Emanuele, Piazza del Duomo, Milan (see nos. 69, 77–84). Although Christo never belonged to the Nouveaux Réalistes group, he exhibited with them on several occasions.

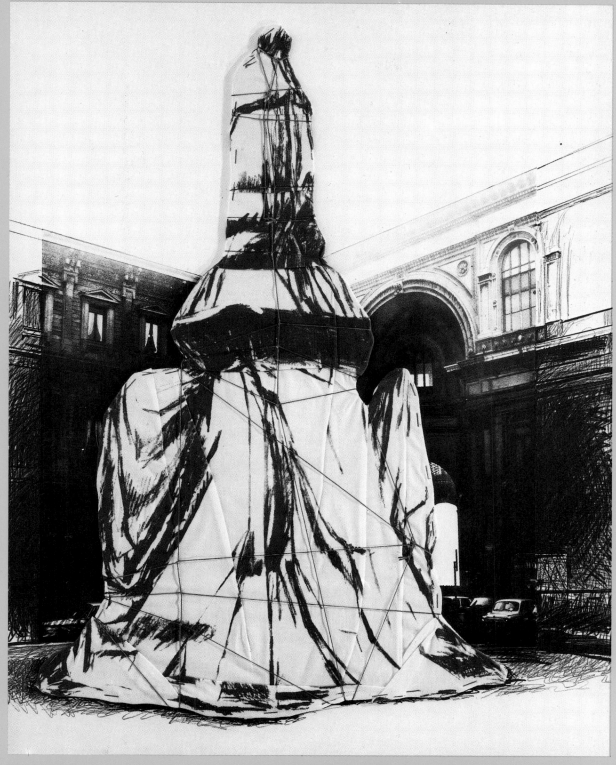

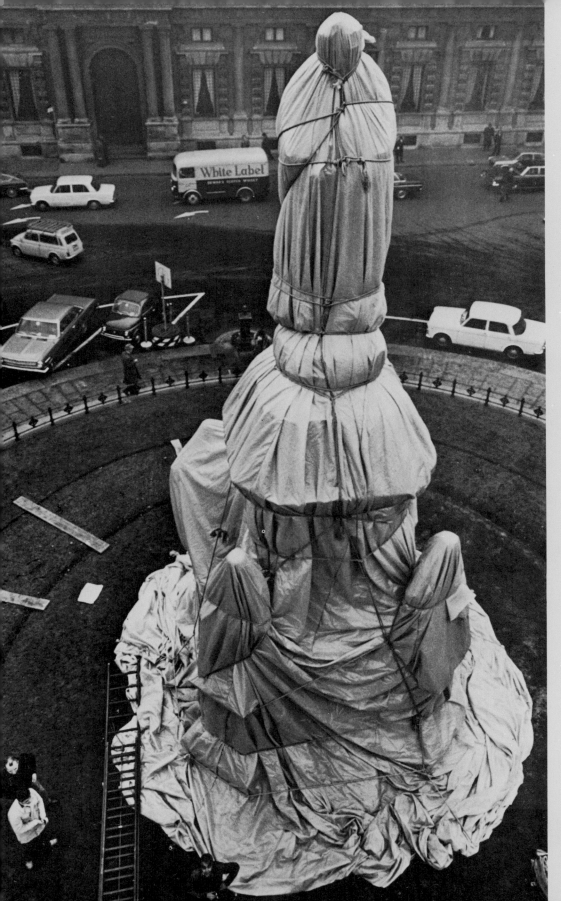

*Wrapped Monument to Leonardo da Vinci*, Milan, 1970.

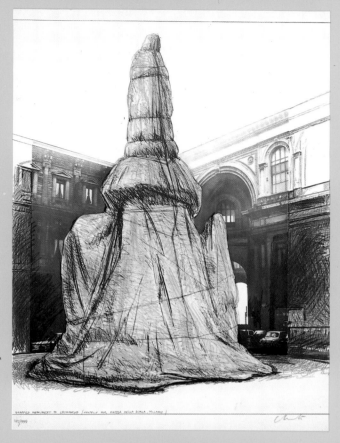

41

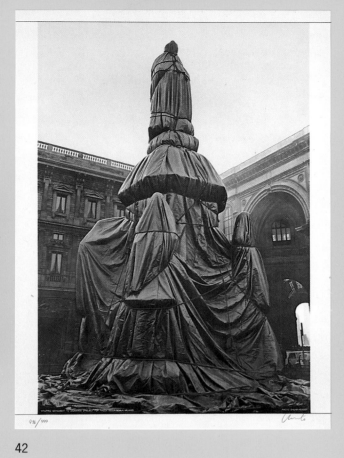

42

## 43 – 46. Packed Kunsthalle Bern, Project

1972
Portfolio with 4 prints:
43. Color screenprint with collage of fabric, twine, and floor plan
44. Screenprint (b/w) with collage of photograph and print
45. Screenprint (b/w)
46. Screenprint (b/w)
Size: nos. 43–45: 27¾ x 21⅝ in.; no. 46: 21⅝ x 27¾ in.
Edition: 135 copies (+ XX A.P.)
Paper: Offset
Photographers: Thomas Cugini, Frank Donell
Printer: Hans-Peter Haas, Stuttgart
Publisher: manus presse, Stuttgart

As part of its fiftieth-anniversary celebration in 1968, the
Kunsthalle Bern gave Christo his first opportunity to package
an entire building. He shrouded the Kunsthalle with 27,000
square feet of reinforced polyethylene left over from the
discarded first skin of the Kassel *Air Package,* secured it with
10,000 feet of nylon rope, and made a slit at the main
entrance so visitors could enter the building.

See nos. 23, 24.

43 – 46   Portfolio box

43

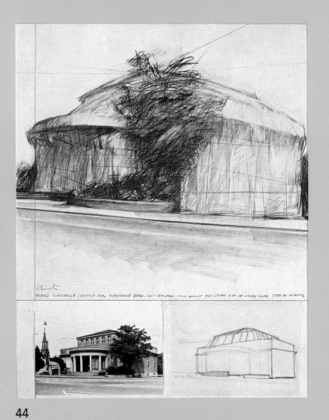

44

45

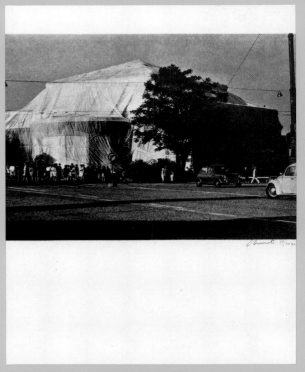

46

## 47 – 49. Double Show Window

1972
Two-part aluminum and Plexiglas objects, in three versions:
47. Green paint on Plexiglas
48. White paint on Plexiglas
49. Brown wrapping paper, taped on Plexiglas
Size: 24 x 36 in.
Edition: no. 47: 20 copies; no. 48: 30 copies;
no. 49: 15 copies; hand painted or hand collaged by Christo
Publisher: Tanglewood Press, New York

This edition was published to raise money for *Running Fence*.

See nos. 5, 6, 16, 93, 102, 104, 105.

47

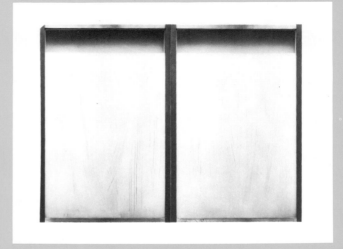

48

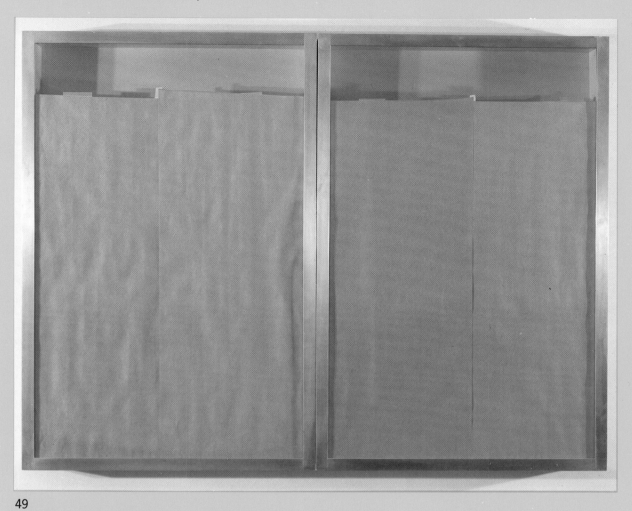

49

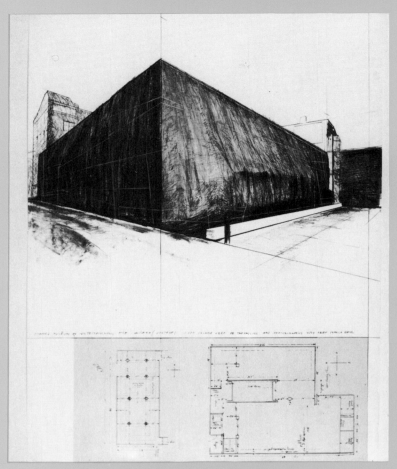

50

## 50. Wrapped Museum of Contemporary Art, Project for Chicago

1972
Color lithograph
Size: 42 x 32 in.
Edition: 60 copies (+ 10 A.P. + 10 S.P.)
Paper: Arjomari
Printer and publisher: Landfall Press, Chicago

This lithograph was published to help finance *Valley Curtain*.

During the winter of 1969, the museum was wrapped for forty-five days in 10,000 feet of heavy dark tarpaulin and 3,600 feet of rope. While the exterior was wrapped, Christo had an exhibition inside: *Wrapped Floor, 2,800 Square Feet*.

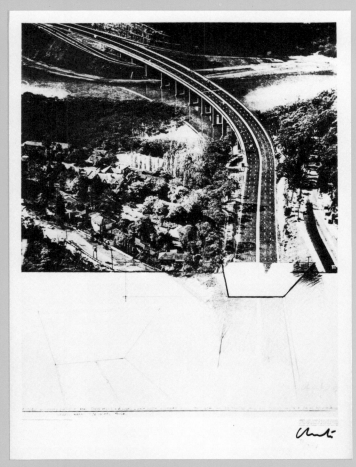

51

## 51. Closed Highway, Project for
## 5000 Miles, 6 Lanes East-West Highway

1972
Offset print (b/w)
Size: 34⅝ x 24 in.
Edition: 200 copies (+ XXV A.P.)
Paper: Offset
Printer: Amalgamated Lithographers of America, New York
Publisher: Local One, New York

Experiment in Art and Technology commissioned this print
– together with prints by other American artists – as part of
a campaign to promote mass transportation.

The project was for a 5000-mile, 6-lane, east-west highway
across the United States; all entrances were to be closed
with a 36-to-48-foot-high glass wall, 36 inches thick.

## 52 – 55. Packed Fountain and Packed Tower, Spoleto, 1968

1972
Portfolio with 4 prints, city map, and text:
52.  Color screenprint with collage of fabric, twine and staples
53.  Screenprint (b/w)
54.  Color screenprint
55.  Screenprint (b/w)
Screenprint (b/w) of city map
Text (not illustrated)
Size: nos. 52, 54, 55: 32½ x 25⅝ in.; no. 53: 25⅝ x 32½ in.
Edition: 100 copies (+ XIV A.P.)
Paper: Fabriano; print no. 52 mounted on board
Photographer: Jeanne-Claude Christo
Printer: Multicenter Grafica, Milan
Publisher: Edizioni Multicenter, Milan

"In 1968, in conjunction with the Festival of the Two Worlds, Christo almost wrapped the Spoleto opera house, the three-story-high Teatro Nuovo, an eighteenth-century building that is one of the principal attractions of the small mountaintop town in central Italy. Christo was prevented from wrapping the building by fire laws. In place of the opera house, he was invited to package a medieval tower on the perimeter of town and a baroque fountain in the center of town, which were wrapped according to his plans, under the direction of his wife, Jeanne-Claude, while the artist himself was in Germany at work on the Kassel *Air Package.*"
From David Bourdon, *Christo,* Harry N. Abrams, New York, 1970.

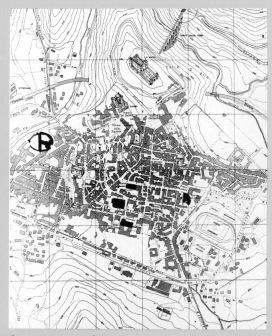

City map in portfolio

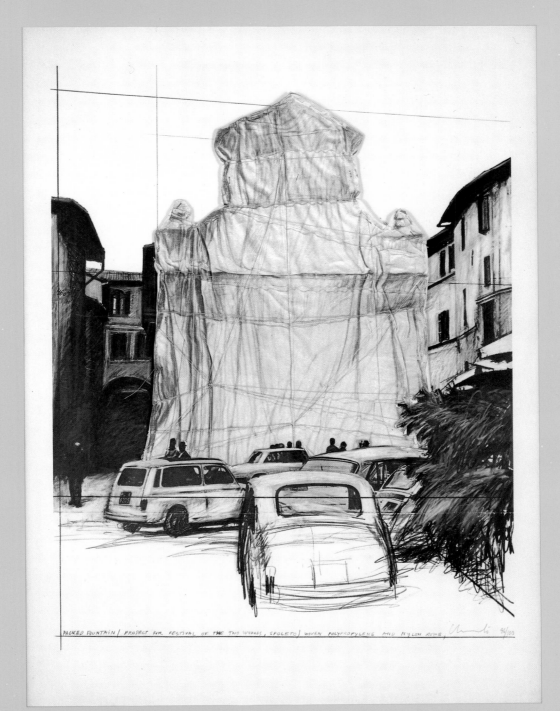

PACKED FOUNTAIN ( PROJECT FOR FESTIVAL OF THE TWO WORLDS, SPOLETO ) WOVEN POLYPROPYLENE AND NYLON ROPE, Christo 96/100

52

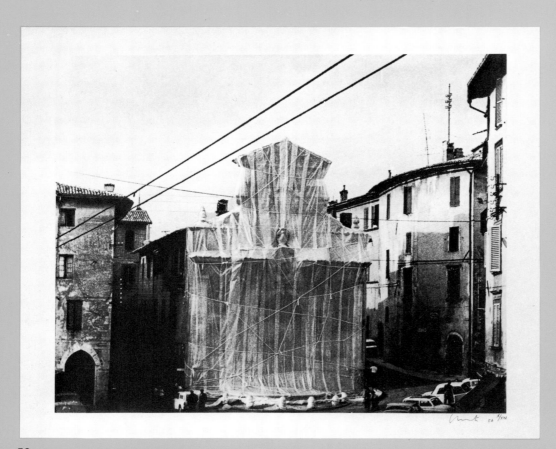

53

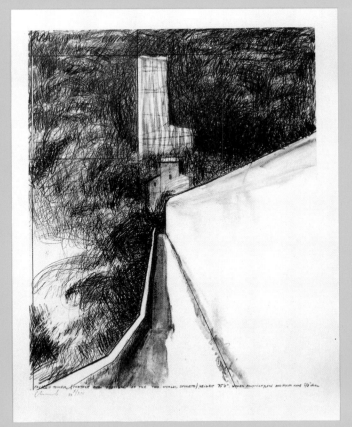

54

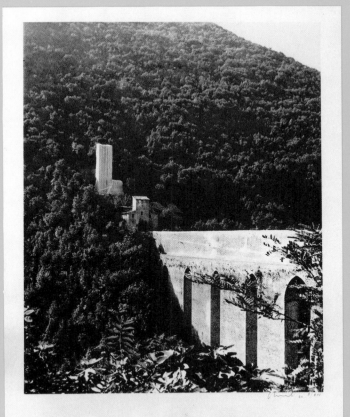

55

## 56 – 58. Ten Million Oil Drums Wall, Project for the Suez Canal

1972
Portfolio with 3 prints, reproduction of photograph,
map, and text:
56. Color screenprint
57. Color screenprint
58. Color screenprint
Screenprint (b/w) from a 1905 photograph,
Color screenprint of a map,
Text by Werner Spies (not illustrated)
Size: 27⅞ x 21⅞ in.
Edition: 70 copies (+ 5 A.P.)
Paper: Bristol board
Photograph: Roger-Viollet press agency, Paris
Printer: Hans-Peter Haas, Stuttgart
Publisher: Fischer Fine Art, London

This project, which originated in 1967, relates to the Egypt-Israel conflict over the Suez Canal. A wall of oil drums floats on the canal, thus closing it. The project represents an expansion of the idea first realized in June 1962 in Rue Visconti, Paris, when the street was closed with a wall of oil drums (see no. 13).

56 – 58   Portfolio box

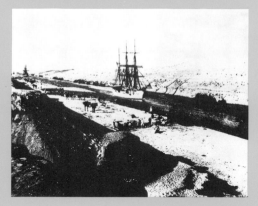

Screenprint from 1905
photograph in portfolio

Map in portfolio

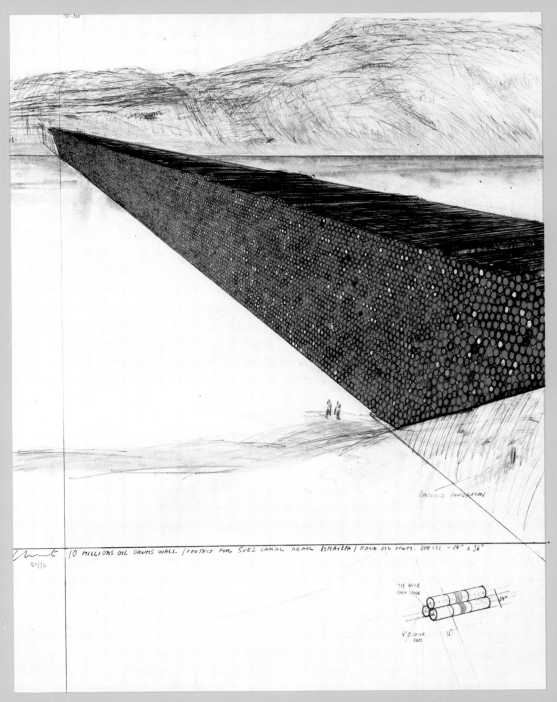

10 MILLIONS OIL DRUMS WALL (PROJECT FOR SUEZ CANAL NEAR ISMAILIA) EACH OIL DRUM: 200 LTS - 24" x 36"

20/70

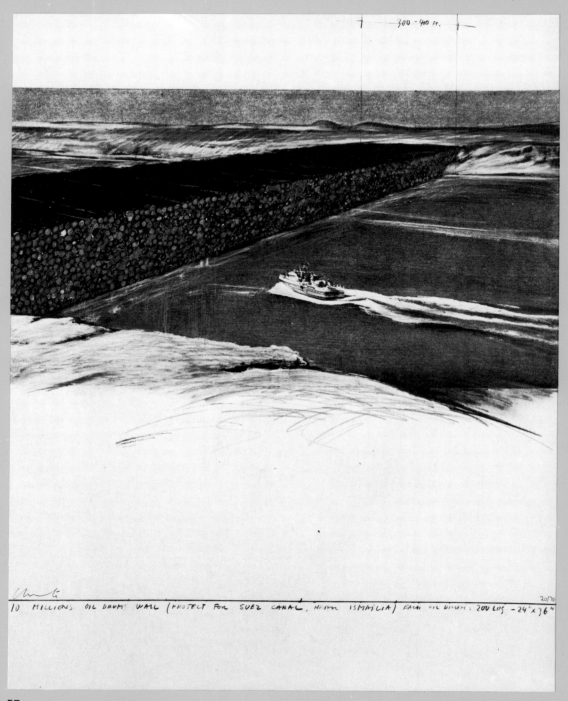

10 MILLIONS OIL DRUMS WALL (PROJECT FOR SUEZ CANAL, NEAR ISMAILIA) EACH OIL DRUM: 200 LBS - 24"x36"

20/70

57

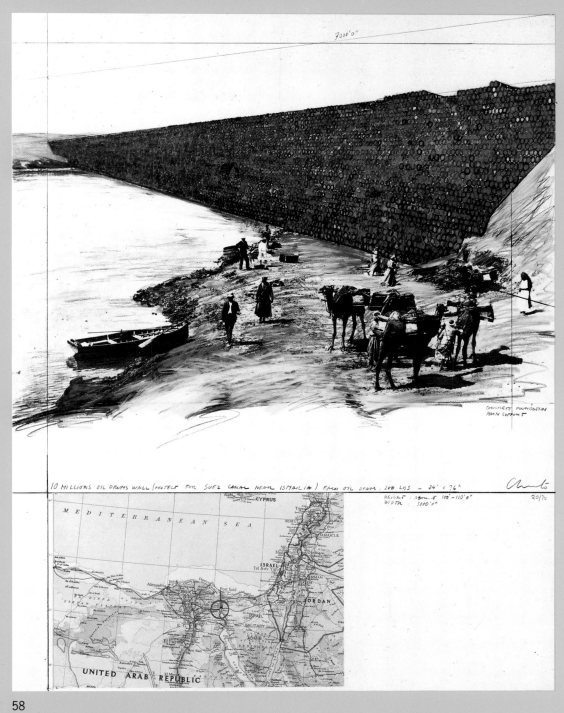

10 MILLIONS OIL DRUMS WALL (PROJECT FOR SUEZ CANAL NEAR ISMAILIA) EACH OIL DRUM. 200 LBS - 24" x 36"

HEIGHT : 100' - 110' 0"
WIDTH : 3000' 0"

20/70

58

59. Wrapped *Sylvette,* Project for
Washington Square Village, New York

1972
Color collotype and color screenprint with collage of
photograph of city map and brown wrapping paper
Size: 25⅝ x 19¾ in.
Edition: 90 copies (+ XXX + V Roman numerals + 40 A.P.)
Paper: Fabriano
Photographer: Harry Shunk
Printer: Domberger KG, Stuttgart
Publisher: Propyläen Verlag, Berlin

This print was part of the portfolio *Hommage à Picasso,* with
works by sixty-nine international artists. The image is based
on the concrete sculpture *Sylvette,* by Pablo Picasso, placed
between two apartment buildings designed by I. M. Pei in
Washington Square Village, Manhattan.

See no. 60.

60. Wrapped *Sylvette,* Project for
Washington Square Village, New York

1973–74
Color collotype and color screenprint with collage of
two photographs
Size: 25⅝ x 19¾ in.
Edition: 300 copies (+ V Roman numerals)
Paper: Fabriano
Photographer: Harry Shunk
Printer: Domberger KG, Stuttgart
Publisher: Propyläen Verlag, Berlin,
for ZEITmagazin-Kunstedition, Hamburg

See no. 59.

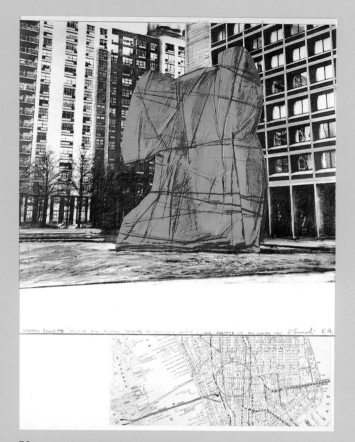

59

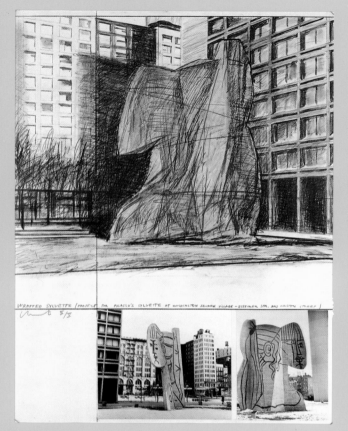

60

## 61. Lower Manhattan Packed Building, 20 Exchange Place, Project for New York

1973
Color screenprint
Size: 27¾ x 21⅞ in.
Edition: 100 copies (+ 10 A.P.)
Paper: 400 g white board
Printer: Hans-Peter Haas, Stuttgart
Publisher: Abrams Original Editions, New York

This print was made to help fund the book *Christo: Valley Curtain,* published by Harry N. Abrams, New York.

The image is a detail of the collage *Two Lower Manhattan Wrapped Buildings, 2 Broadway and 20 Exchange Place, Project for New York,* made in 1964, shortly after Christo arrived in New York.

See nos. 14, 106, 118, 127.

## 62. Packed Hay, Project for the Institute of Contemporary Art, Philadelphia

1973
Color screenprint
Size: 22 x 30 in.
Edition: 200 copies
Paper: Brown cardboard
Printer: Hans-Peter Haas, Stuttgart
Publisher: Kestner-Gesellschaft, Hannover

In 1968 Christo created *Packed Hay* (12 x 20 x 8 feet) as part of his exhibition at the Philadelphia Institute of Contemporary Art.

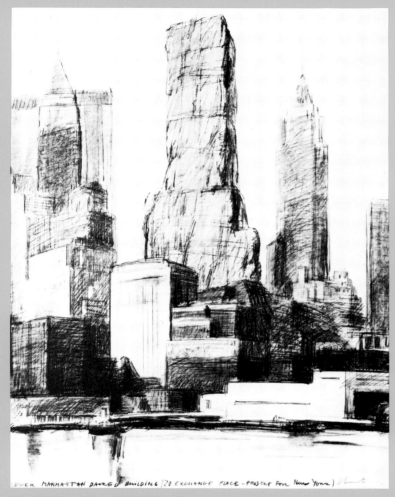

LOWER MANHATTAN PACKED BUILDING (20 EXCHANGE PLACE - PROJECT FOR New York)

61

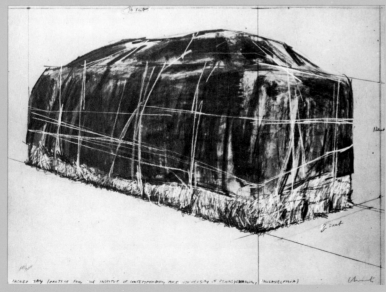

PACKED TREE (PROJECT FOR THE INSTITUTE OF CONTEMPORARY ARTS UNIVERSITY OF PENNSYLVANIA, PHILADELPHIA)

62

### 63. Wrapped Woman, Project for the Institute of Contemporary Art, Philadelphia

1973
Color screenprint
Size: 28 x 22 in.
Edition: 120 copies (+ 25 A.P.)
Paper: White board
Printer: Hans-Peter Haas, Stuttgart
Publisher: Verlag Gerd Hatje, Stuttgart

Christo made this print to help fund the publication of the book *Christo: Valley Curtain,* published by Verlag Gerd Hatje, Stuttgart.

The first wrapping of a woman took place in Paris in 1962. For the opening of Christo's 1968 exhibition at the Institute of Contemporary Art, University of Pennsylvania, seven young women were wrapped in polyethylene and rope. They were placed lying on large pedestals and remained wrapped for five hours.

WRAPPED WOMAN (PROJECT FOR INSTITUT OF CONTEMPORARY ART - UNIVERSITY OF PENNSYLVANIA)

63

Christo wrapping one of seven young women at the Philadelphia Institute of Contemporary Art, 1968.

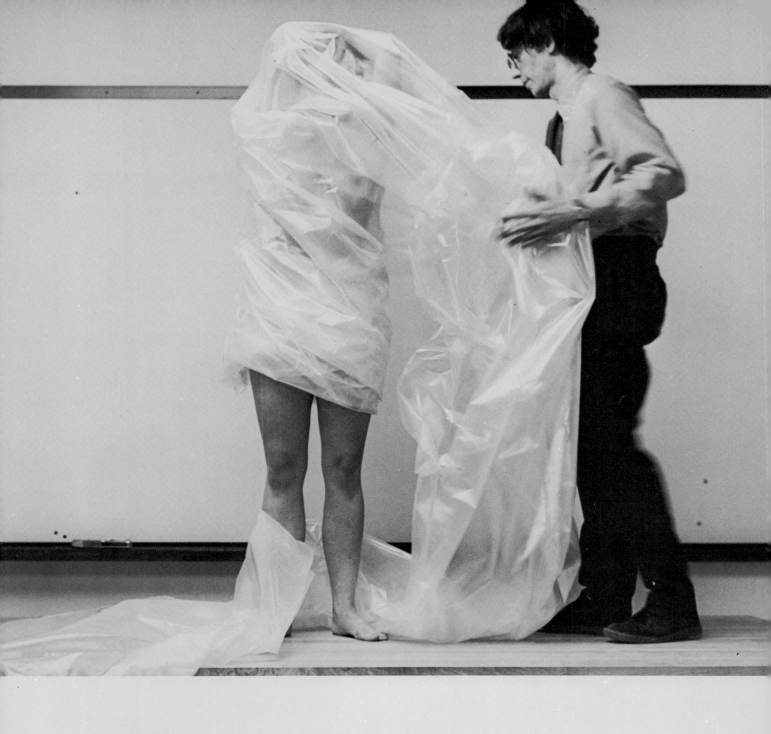

64 – 67. Valley Curtain, Rifle, Colorado, 1970–72

1973
Four color offset prints
Size: 33⅛ x 23¼ in.
Edition: 120 copies (+ 30 A.P.)
Paper: Offset
Photographer: Harry Shunk
Printer: Alfred Holle, Düsseldorf
Publisher: Kunsthalle Düsseldorf; Louisiana Museum,
Humlebaek, Denmark; Henie-Onstad Foundation, Oslo;
La Rotonda, City of Milan

This series of prints was made for the European tour of the
exhibition documenting *Valley Curtain*. The same images
were used as posters for the exhibition.

*Valley Curtain* was started in 1970 and completed on
August 10, 1972, at Rifle Gap, Colorado. The curtain was
made of 200,000 square feet of translucent orange woven
nylon polyamide, 110,000 pounds of steel cables, and 800
tons of concrete for the foundations. *Valley Curtain* measured
1,313 feet wide, with a height of 365 feet at each end and
182 feet at the center. On August 11, 28 hours after
completion, a gale made it necessary to dismantle the
project.

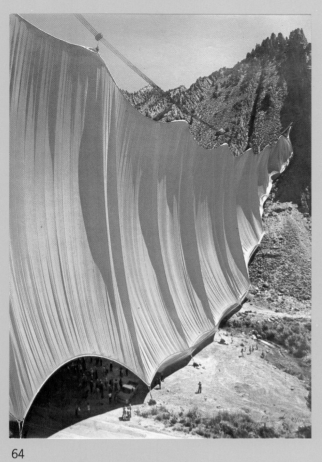

64

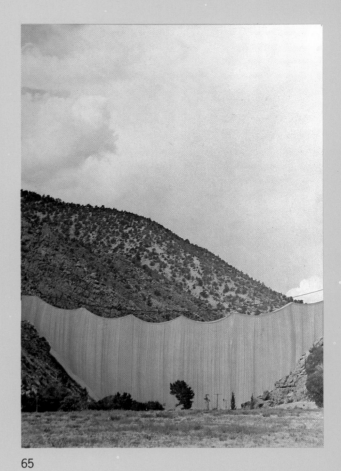

65

*Valley Curtain,* 1972. Iron workers, 185 feet above ground, installing one of the eleven cable clamps, which weighed 600 pounds each.

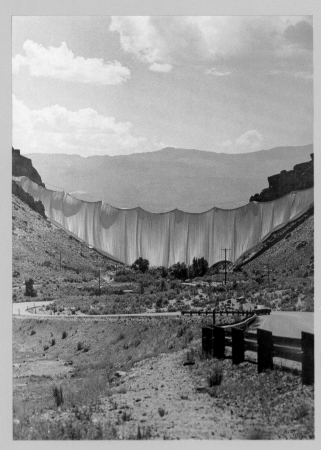

66

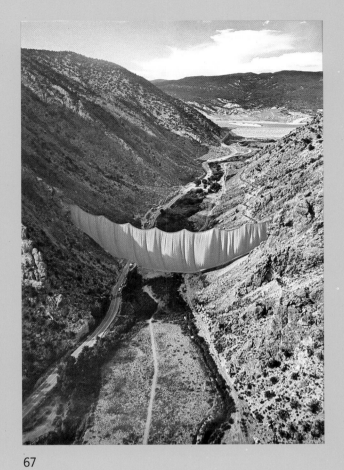

67

## 68. Wrapped Book

1973
The book *Christo* wrapped in canvas with twine
Size: 12 x 11¼ x 1⅜ in.
Edition: 100 copies (+ 10 A.P.), handmade by Christo
Publisher: Abrams Original Editions, New York

Christo made this edition to help fund the publication
of the book *Christo* by David Bourdon, published by
Harry N. Abrams, New York.

## 69. Wrapped Monument to Vittorio Emanuele, Piazza del Duomo, Milan, 1970

1973
Photograph (b/w)
Size: 19¾ x 19¾ in.
Edition: 600 copies, signed by Christo and Harry Shunk
Photographer: Harry Shunk
Publisher: Attilo Codognato, Venice

See nos. 77–84 for project description.

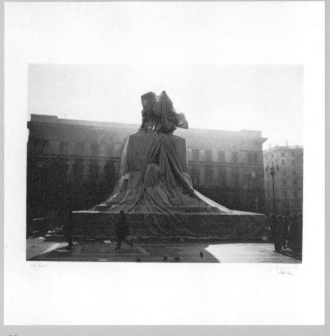

69

68

## 70 – 73. Wrapped Roman Wall, Porta Pinciana, Rome, 1974

1974
Four (b/w) photographs
Size: nos. 70, 71: 15¾ x 11¾ in.; nos. 72, 73: 11¾ x 15¾ in.
Edition: 50 copies
Photographer: Massimo Piersanti
Publisher: Incontri Internazionali d'Arte, Rome

In January 1974 Christo wrapped the four arches of the Porta Pinciana, one of the gates of the 1700-year-old Roman wall, using 73,400 square feet of woven polypropylene fabric and 9,850 feet of rope. The wrapping stayed for nearly two months. The project was part of the exhibition *Contemporanea,* which took place in the underground garage of the Villa Borghese. Christo had originally wanted to wrap the Ponte S. Angelo (see no. 123) but could not get permission.

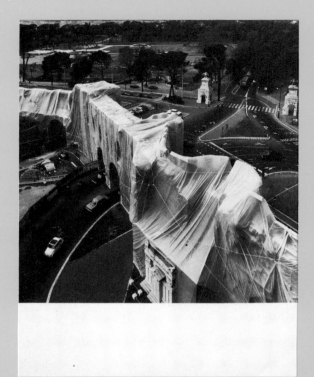

70

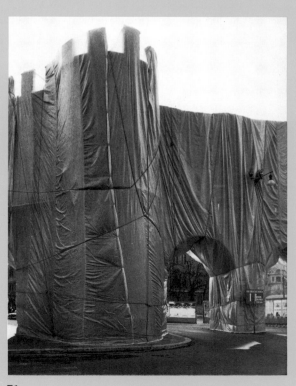

71

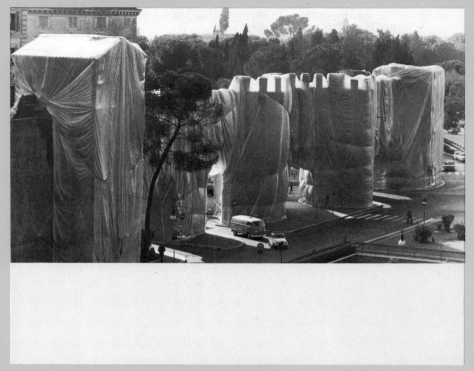

72

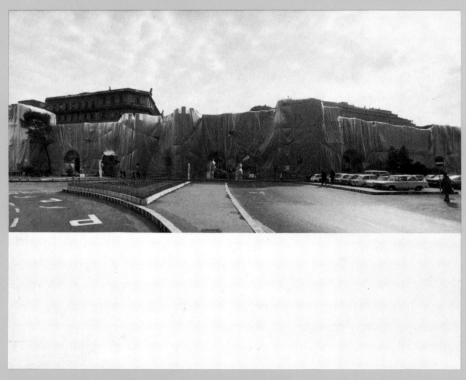

73

## 74. Wrapped Venus, Project for Villa Borghese, Rome

1974
Lithograph
Size: 25⅝ x 19¾ in.
Edition: 200 copies (+ XXXV Roman numerals + X A.P.)
Paper: Special Arjomari
Printer: Landfall Press, Chicago
Publisher: Christo for Schweizerischer Kunstverein,
St. Gallen

The Venus had been wrapped in December 1963, without permission from the authorities, and had remained wrapped for four months. Nobody reacted to the statue's having been wrapped, since it was commonly believed that the wrapping had been undertaken by the park authorities for conservation purposes.

See no. 75.

## 75. Wrapped Venus, Project for Villa Borghese, Rome

1975
Etching and color lithograph with collage of transfer paper
Size: 28 x 22 in.
Edition: 50 copies (+ XXV Roman numerals + 12 A.P. + 5 S.P.)
Paper: Handmade Twinrocker
Printer and publisher: Landfall Press, Chicago

Together with works by William Allan, Robert Cottingham, Claes Oldenburg, Philip Pearlstein, and William T. Wiley, this piece was included in the *Landfall Press Etching Portfolio*.

See no. 74.

74

75

## 76. Wrapped Coast, Little Bay, Australia, One Million Square Feet, 1969

1975
Color collotype
Size: 13 x 15¾ in.
Edition: 55 copies (+ VIII Roman numerals)
Paper: Ivory
Photographer: Harry Shunk
Printer: Schreiber, Stuttgart
Publisher: Edition Schellmann, Munich

This was included in the portfolio *Landscapes* with works by Jan Dibbets, Richard Hamilton, and Dennis Oppenheim.

"Little Bay is located 9 miles south-east of the center of Sydney. The cliff-lined shore area that was wrapped was approximately 1½ miles in length, 150 to 800 feet in width, and 85 feet in height. One million square feet of erosion control mesh (synthetic woven fiber usually manufactured for agricultural purposes) was used for the wrapping. Thirty-five miles of polypropylene rope tied the fabric to the rocks. Ramset guns fired 25,000 charges of fastenings, threaded studs, and clips to secure the rope to the rocks.

"Fifteen professional mountain climbers, 110 labourers, students from Sydney University and East Sydney Technical College, as well as some Australian artists and teachers put in 17,000 manpower hours over a period of four weeks. The coast remained wrapped for a period of ten weeks, then all materials were removed and the site restored to its original condition.

"*Wrapped Coast* was financed by Christo through the sale of his preparatory drawings, collages, studies, and early works." From press release of the project, 1969.

See no. 30.

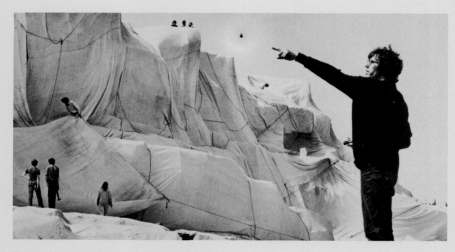

Christo during installation of *Wrapped Coast,* 1969.

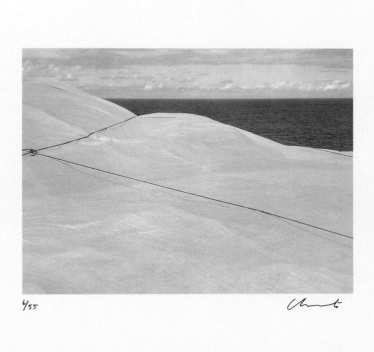

4/55                    Christo

76

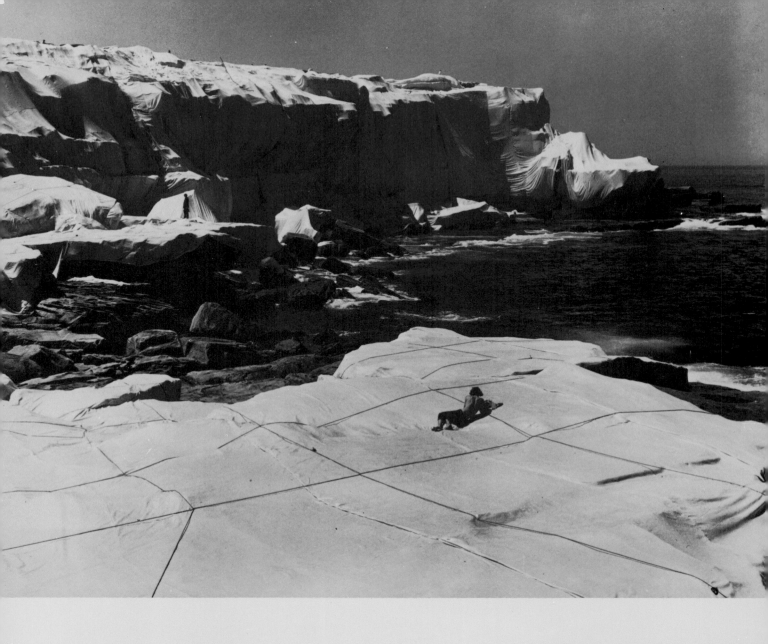

*Wrapped Coast, Little Bay, Australia, One Million Square Feet*, 1969.

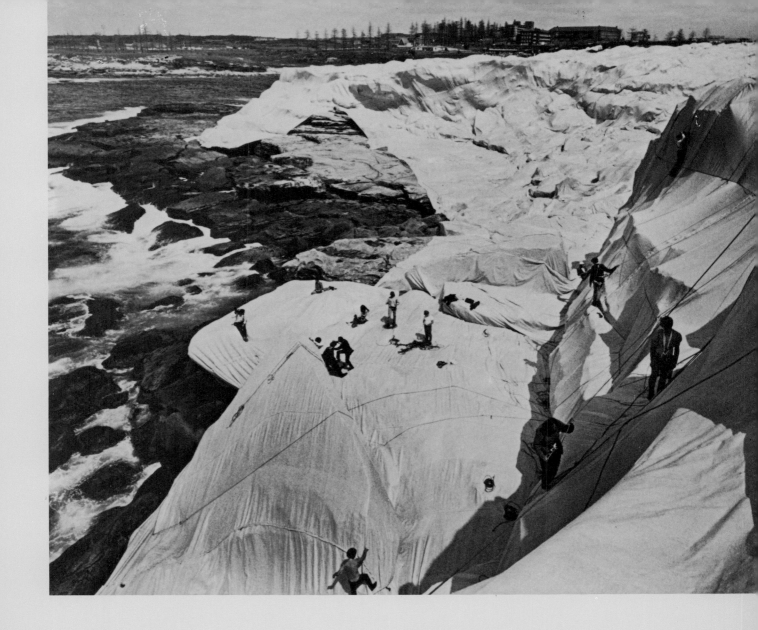

<u>77 – 84. Wrapped Monument to Vittorio Emanuele,</u>
<u>Project for Piazza del Duomo, Milan</u>

1975
Portfolio with 5 prints, 3 photographs, and text:
77, 78. Color lithographs with collage of fabric, twine,
    and staples
79.  Color lithograph with collage of brown wrapping paper
80.  Color lithograph
81.  Color lithograph with collage of sheet of text,
    photograph, and masking tape
82, 83, 84. Photographs (b/w)
Text by Tommaso Trini (not illustrated)
Size: nos. 77–81, 84: 28 x 22 in.; nos. 82, 83: 22 x 28 in.
Edition: 75 copies (+ 10 A.P. + 10 H.C.)
Paper: nos. 77–81: Guarro;
nos. 82–84: mounted on heavy cardboard
Photographer: Ugo Mulas
Printer: La Poligrafa, Barcelona
Publisher: Ediciones Poligrafa, Barcelona

In 1970 Christo wrapped Milan's monument to Vittorio
Emanuele, the last king of Italy. After the wrapping was
completed, a strike broke out and the wrapped monument
was used as a stand for speakers during strike meetings in
the Piazza del Duomo. The monument stayed wrapped for
forty-four hours.

See no. 69.

77 – 84   Portfolio box

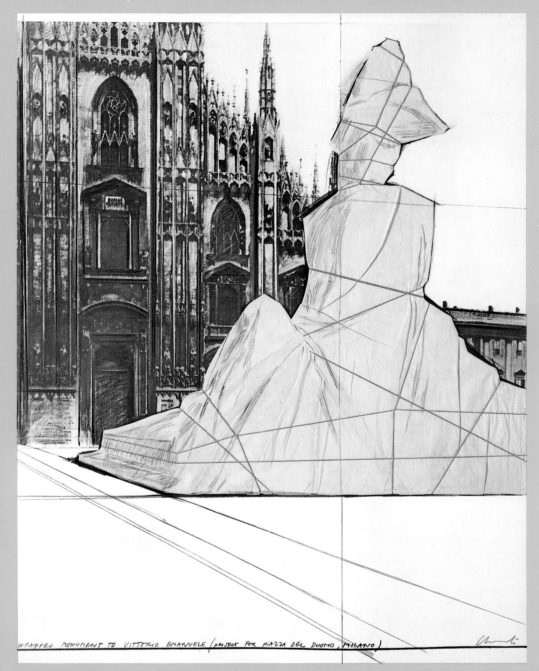

WRAPPED MONUMENT TO VITTORIO EMANUELE (PROJECT FOR PIAZZA DEL DUOMO, MILANO)

77

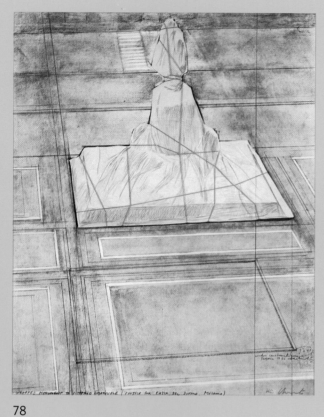

78

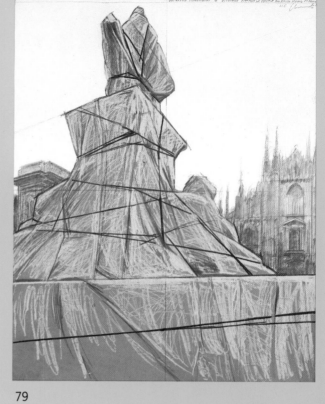

79

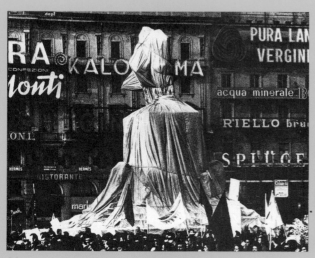

82

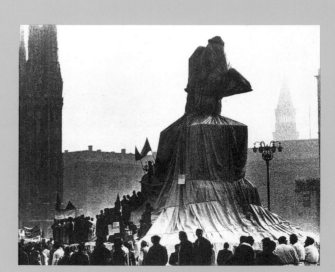

83

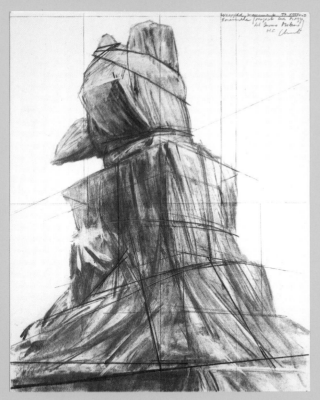

80

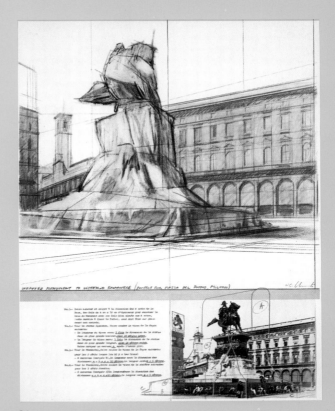

81

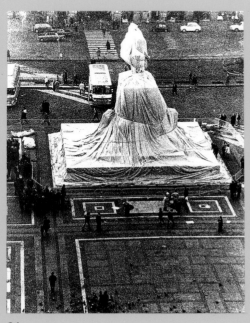

84

## 85. Texas Mastaba,
## Project for 500,000 Stacked Oil Drums

1976
Lithograph with collage of color silkscreen
Size: 30 x 22¼ in.
Edition: 200 copies (+ 25 A.P. + 20 H.C.)
Paper: Brown cardboard
Printer: Styria Studio, New York
Publisher: APC Editions, Chermayeff and
Geismer Associates, New York

This print was part of the portfolio *America: The Third Century,* which included the works of thirteen American artists and was published in commemoration of the Bicentennial.

See no. 89 for project description.

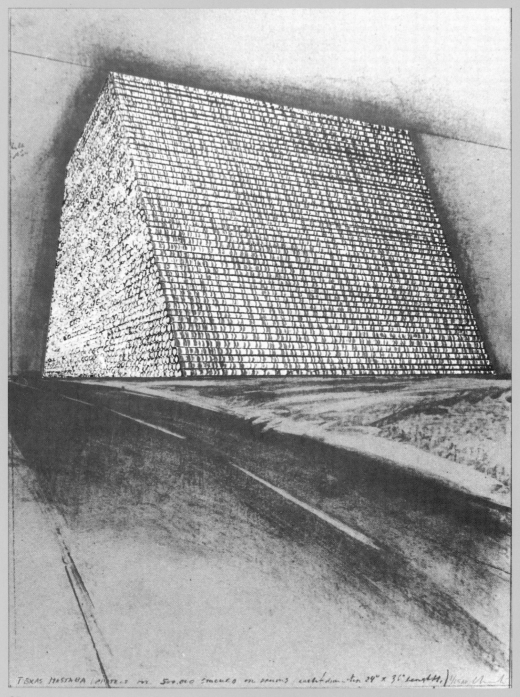

TEXAS MASTABA (Project for 500,000 stacked oil drums each diameter 24" x 36" Length 44') 1/15/76 Christo

85

## 86. Wrapped Bridge,
## Project for Le Pont Alexandre III, Paris

1977
Color lithograph with photograph attached
Size: 28 x 22 in.
Edition: 66 + 33 copies
Paper: Edition of 66 copies on 260 g Rives;
edition of 33 copies on Japanese paper
Photographer: Harry Shunk
Printer: Matthieu AG, Zurich
Publisher: Grafos Verlag, Vaduz, Liechtenstein

Christo made a few drawings and collages for *Wrapped Bridge, Project for Le Pont Alexandre III, Paris,* before he resolved to wrap the Pont-Neuf.

*The Pont-Neuf, Wrapped, Paris, 1975–85* was realized on September 22 and disassembled on October 7, 1985. The temporary wrapping of the 400-year-old Pont-Neuf was designed to continue the successive metamorphoses that the bridge had undergone through history. It became, for fourteen days, a work of art in itself.

The shiny sandstone-colored cloth (440,000 square feet of woven polyamide fabric) was held to the bridge's surface by 42,900 feet of rope. The wrapping maintained the principal shapes of the bridge, accentuating reliefs while generalizing proportions and details.

All expenses related to *The Pont-Neuf, Wrapped* were borne by the artist through the sale of his preparatory drawings and collages as well as earlier works.

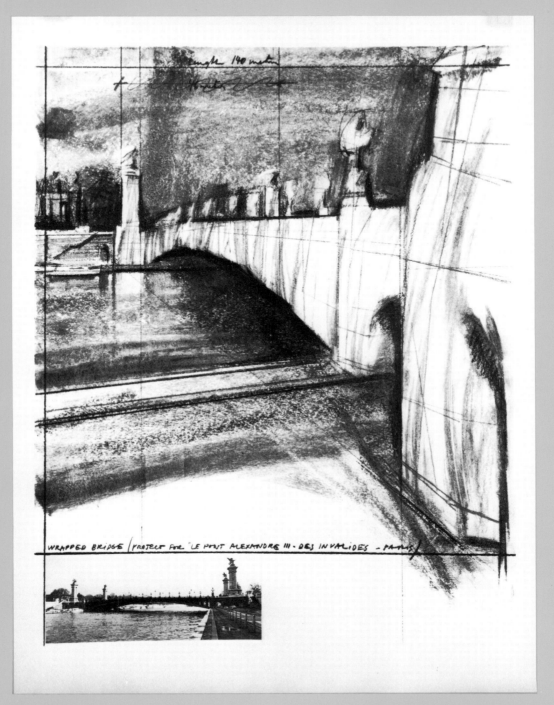

WRAPPED BRIDGE / PROJECT FOR "LE PONT ALEXANDRE III · DES INVALIDES · PARIS/

86

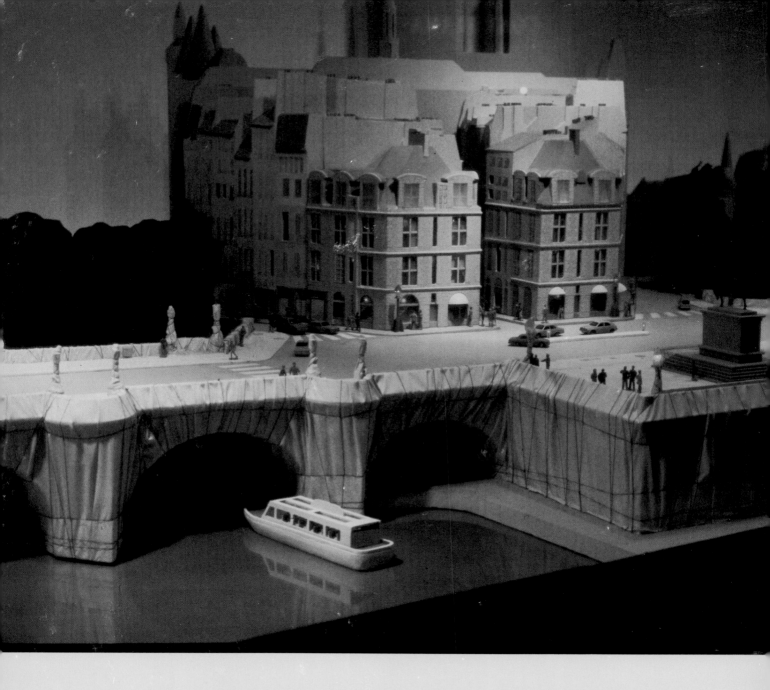

Scale model of *The Pont-Neuf, Wrapped, Project for Paris,* 1981.

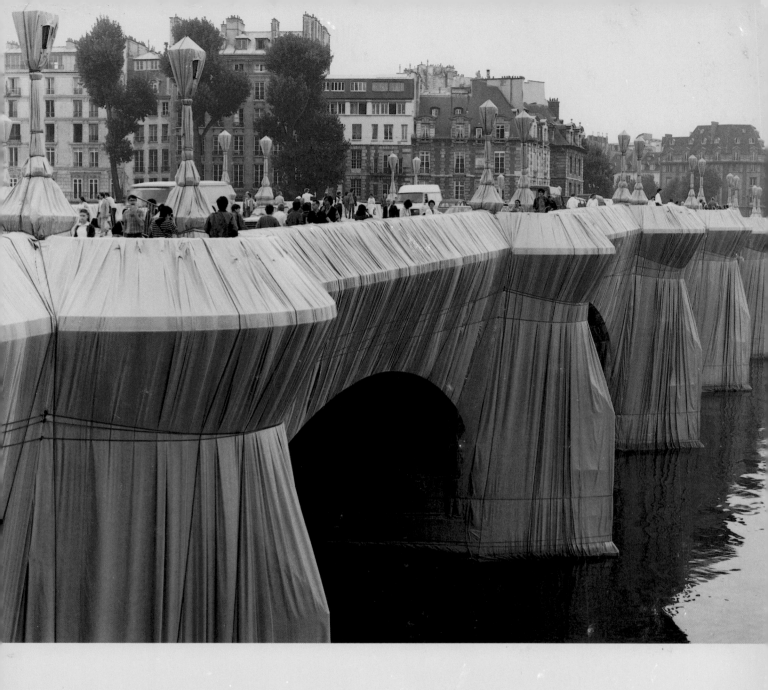

*The Pont-Neuf, Wrapped*, Paris, 1985.

## 87. Running Fence,
## Sonoma and Marin Counties, California, 1972–76

1977
Color offset print
Size: 25 x 39 in.
Edition: 750 copies
Paper: White board
Photographer: Gianfranco Gorgoni
Printer: Johnson Printing, Minneapolis
Publisher: Young Presidents' Organization, New York

Christo and Jeanne-Claude were invited to lecture about financial and organizational aspects of *Running Fence* at the annual meeting of the Young Presidents' Organization in 1977, which took place in Hawaii. The print was published for this occasion and distributed to the YPO members.

See nos. 96–100 for project description.
See also no. 109.

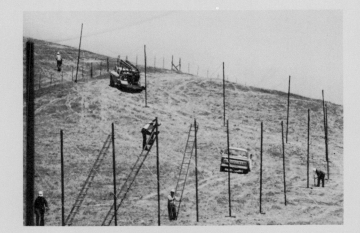

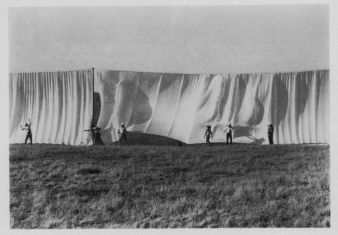

*Running Fence* during construction, 1976.

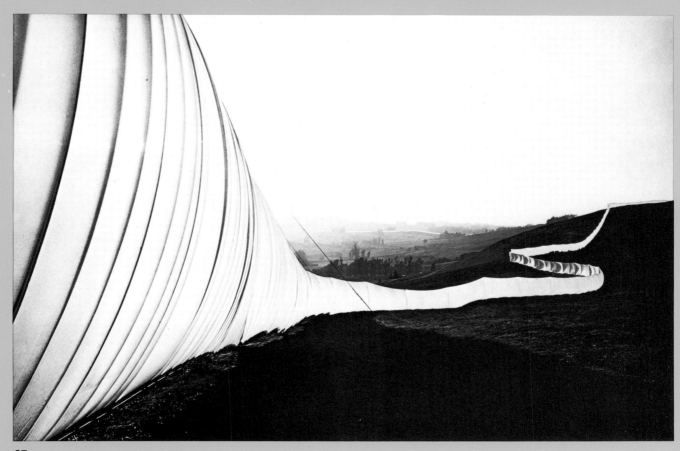

87

## 88. Wrapped Armchair, Project

1977
Color lithograph
Size: 22 x 28 in.
Edition: 100 copies (+ 15 A.P.)
Paper: Rives Couronne
Printer: Matthieu AG, Zurich
Publisher: Abrams Original Editions, New York

Christo donated this edition to help fund the publication of the book *Christo: The Running Fence* by Werner Spies and Wolfgang Volz, published by Harry N. Abrams, New York.

Christo had done several *Wrapped Chairs* as early as 1958. The first *Wrapped Armchair* was made for his 1966 exhibition in the Stedelijk Van Abbemuseum, Eindhoven.

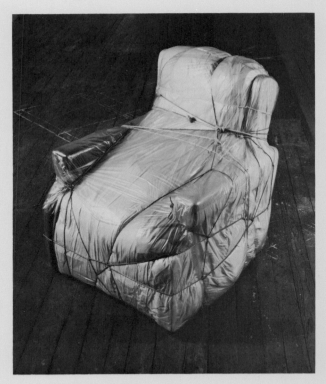

*Wrapped Armchair*, 1966.
Stedelijk Van Abbemuseum, Eindhoven

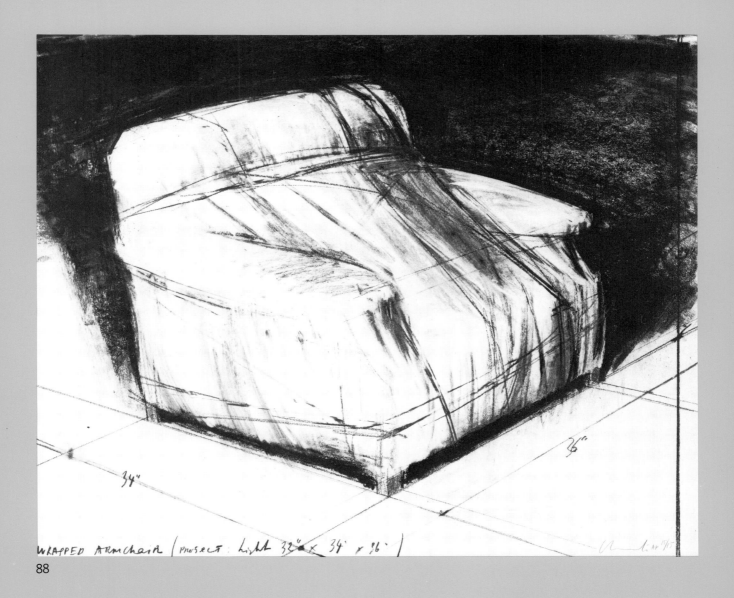

WRAPPED ARMCHAIR (project: light 32" x 34" x 36")

88

## 89. Texas Mastaba,
## Project for 500,000 Stacked Oil Drums

1977
Color screenprint
Size: 27⅞ x 21⅞ in.
Edition: 120 copies (+ 20 A.P.)
Paper: White board
Printer: Hans-Peter Haas, Stuttgart
Publisher: Verlag Gerd Hatje, Stuttgart

Christo made this edition to help fund the publication of the book *Christo: The Running Fence* by Werner Spies and Wolfgang Volz, published by Verlag Gerd Hatje, Stuttgart.

A mastaba is an ancient Egyptian tomb used long before the pyramid. Christo had used the mastaba shape in 1961 in Cologne (see no. 130) and his first large-scale mastaba, built out of 1,240 oil barrels, was made for the Institute of Contemporary Art, Philadelphia, in 1968. The print illustrated is based on a project for a large outdoor mastaba south of Houston, Texas, which was turned down by the oil companies that had been asked to sponsor the project. A smaller version was proposed for the Rijksmuseum Kröller-Müller, Otterlo, but was not accepted. In 1979 Christo started work on *The Mastaba of Abu Dhabi, Project for the United Arab Emirates,* built out of 390,500 multicolored stacked oil barrels.

See no. 85.

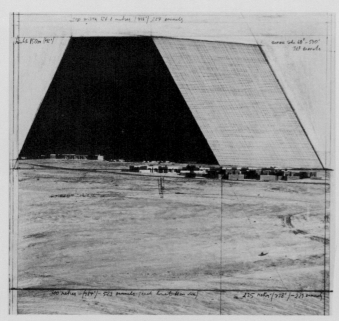

*The Mastaba of Abu Dhabi, Project for the United Arab Emirates,* 1979, collage (detail).

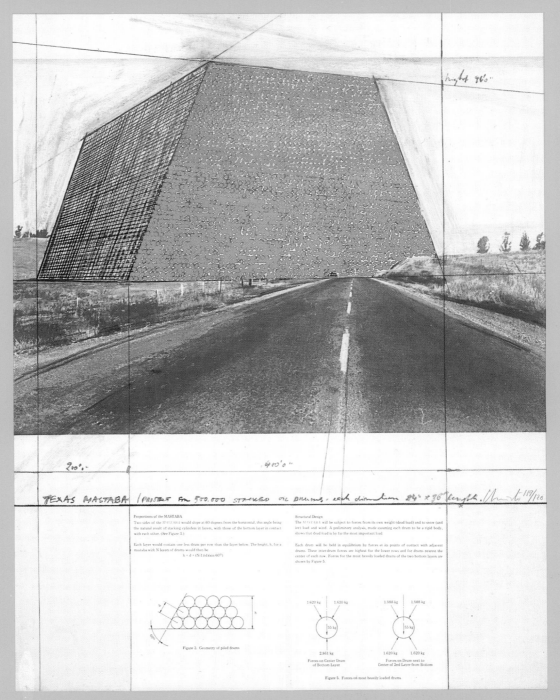

height 96'0"

200'0"          400'0"

TEXAS MASTABA (PROJECT) for 500,000 STACKED OIL DRUMS - each dimension 24" x 36" length.  Christo 119/120

**Proportions of the MASTABA**

Two sides of the MASTABA would slope at 60 degrees from the horizontal, this angle being the natural result of stacking cylinders in layers, with those of the bottom layer in contact with each other. (See Figure 3.)

Each layer would contain one less drum per row than the layer below. The height, h, for a mastaba with N layers of drums would then be

$$h = d + (N-1)d \sin 60°)$$

**Structural Design**

The MASTABA will be subject to forces from its own weight (dead load) and to snow (and ice) load and wind. A preliminary analysis, made assuming each drum to be a rigid body, shows that dead load is by far the most important load.

Each drum will be held in equilibrium by forces at its points of contact with adjacent drums. These inter-drum forces are highest for the lower rows and for drums nearest the center of each row. Forces for the most heavily loaded drums of the two bottom layers are shown by Figure 5.

Figure 3.  Geometry of piled drums

1,620 kg   1,620 kg        1,588 kg   1,588 kg

55 kg                          55 kg

2,861 kg                   1,620 kg   1,620 kg

Forces on Center Drum        Forces on Drum next to
of Bottom Layer              Center of 2nd Layer from Bottom

Figure 5.  Forces on most heavily loaded drums

89

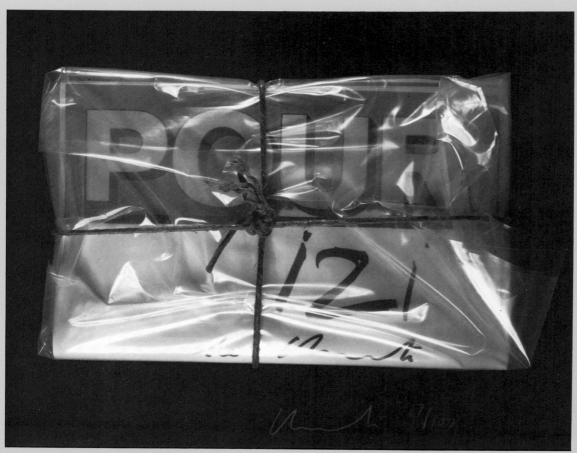

90

## 90. *Pour* Journal, Wrapped

1977
*Pour* journal folded and wrapped in transparent
polyethylene with cord, mounted on black cardboard
Size (of cardboard): 11 x 13⅜ x 2 in.
Edition: 100 copies, handmade by Christo
Publisher: Isi Fiszman, Brussels

This edition was published along with works by other artists
to support the radical Belgian journal *Pour*.

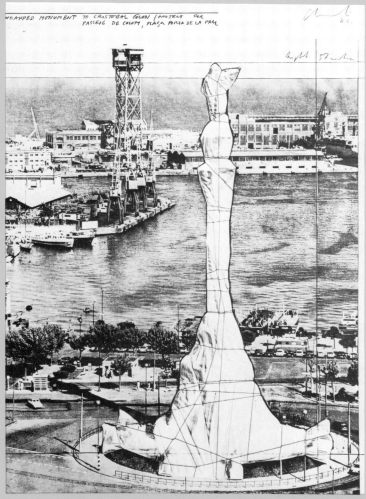

91

## 91. Wrapped Monument to Cristóbal Colón, Project for Barcelona

1977
Color lithograph
Size: 30 x 22 in.
Edition: 75 copies (+ 10 A.P. + 10 H.C.)
Paper: Guarro
Photographer: Wolfgang Volz
Printer: La Poligrafa, Barcelona
Publisher: Ediciones Poligrafa, Barcelona

In February 1984 the mayor of Barcelona gave permission, which Christo had been requesting since 1975, to wrap the monument to Christopher Columbus. In the meantime, however, Christo had focused on larger projects and he therefore canceled this one.

## 92. *Die Zeit* Newspapers, Wrapped

1977
Pile of 8 folded copies of *Die Zeit* newspaper and photograph
wrapped in transparent polyethylene with twine and staples
Size: approx. 13½ x 10¼ x 6 in.
Edition: 6 copies, handmade by Christo
Publisher: DIE ZEIT, Hamburg

This edition was published on the occasion of Christo's visit
to the editorial office of *Die Zeit,* Hamburg, in 1977. Each
number of the edition contains a photograph of one of the
six cultural editors of the newspaper.

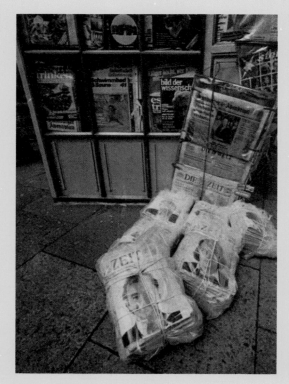

Stacks of *Die Zeit Newspapers, Wrapped*
at a newsstand in Hamburg, 1977.

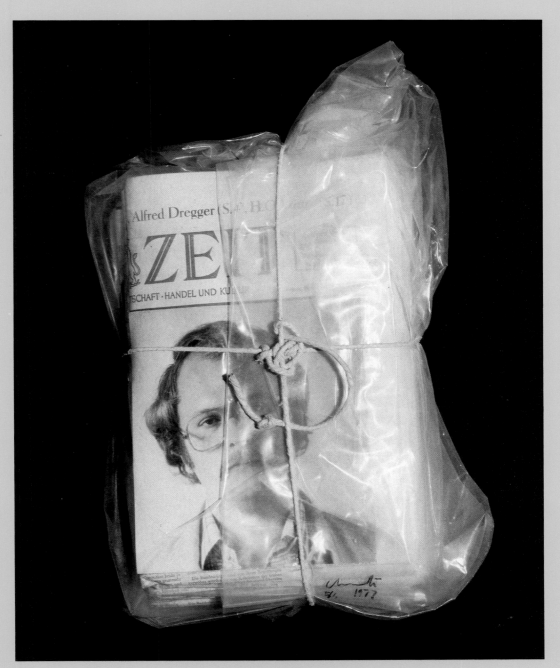

92

## 93. Red Store Front, Project

1977
Color screenprint with collage of brown wrapping paper
Size: 28 x 21⅞ in.
Edition: 110 copies (+ 20 A.P.)
Paper: White board
Printer: Hans-Peter Haas, Stuttgart
Publisher: Verlag Gerd Hatje, Stuttgart, and
Edition Schellmann & Klüser, Munich

This edition was made to help fund the publication of the book *Christo: The Running Fence* by Werner Spies and Wolfgang Volz, published by Verlag Gerd Hatje, Stuttgart.

See nos. 5, 6, 16, 47–49, 102, 104, 105.

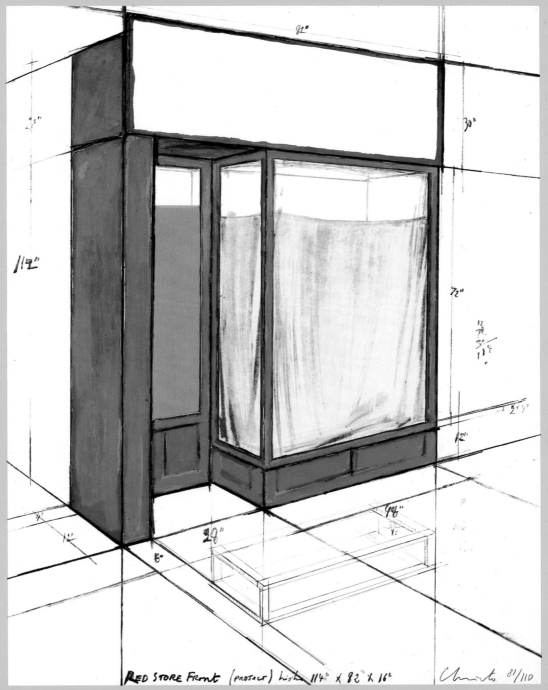

RED STORE FRONT (PROJECT) High 114" x 82" x 16"        Christo 81/110

93

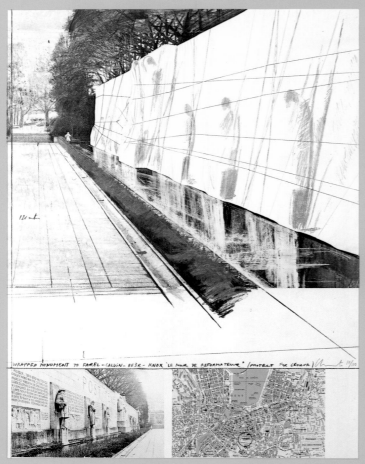

94

## 94. Wrapped *Mur des Réformateurs,* Project for Geneva

1977
Color lithograph with collage of fabric, twine, photograph,
and city map
Size: 28⅛ x 22 in.
Edition: 100 copies (+ 10 A.P.)
Paper: Rives, mounted on cardboard
Photographer: Wolfgang Volz
Printer: Matthieu AG, Zurich
Publisher: Graphik International, Stuttgart

This project was planned as one of three wrappings of
Geneva landmarks: the monument to Farel, Calvin, de Bèze,
and Knox *(Mur des Réformateurs),* the fountain in Lake
Leman, and the equestrian statue of General Dufour.
The projects were never realized.

Christo lived in Geneva in the winter of 1957–58 before he
went to Paris.

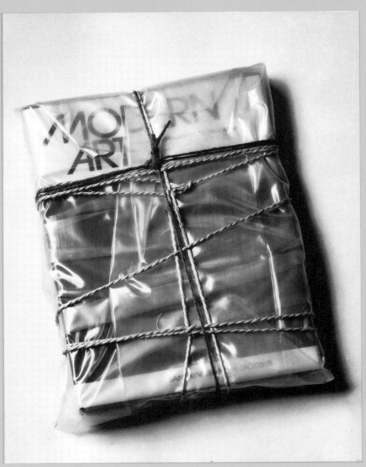

95

## 95. Wrapped Book *Modern Art*

1978
The book *Modern Art,* by Sam Hunter and John Jacobus,
wrapped in transparent polyethylene with twine and cord
Size: 13⅝ x 10 x 1¾ in.
Edition: 120 copies (+ 20 A.P.)
Publisher: Abrams Original Editions, New York

Christo made this edition to help fund the publication of the
book *Christo: Running Fence* by Calvin Tomkins, David
Bourdon, and Gianfranco Gorgoni, published by Harry N.
Abrams, New York.

## 96 – 100. Running Fence,
### Sonoma and Marin Counties, California, 1972–76

1979
Five dye-transfer color photographs
Size: 19¾ x 23⅝ in.
Edition: 50 copies, signed by Christo and Wolfgang Volz
Photographer: Wolfgang Volz
Publisher: Galerie Habermann, Göttingen,
and Wolfgang Volz

Christo signed this edition to thank his friend and photographer Wolfgang Volz.

"*Running Fence,* 18 feet high and 24½ miles long, extended east-west near Freeway 101, north of San Francisco, on the private properties of 59 ranchers, following the rolling hills and dropping down to the Pacific Ocean at Bodega Bay. It crossed 14 roads and the town of Valley Ford, leaving passage for cars, cattle and wildlife. *Running Fence* was completed on September 10, 1976.

"The art project involved 42 months of collaborative efforts, the rancher's participation, 18 public hearings, 3 sessions at the Superior Court of California, the drafting of a 450 page Environmental Impact Report and the temporary use of the hills, the sky and the ocean. Conceived and financed by Christo, *Running Fence* was made of 165,000 yards of heavy woven white nylon fabric, hung from a steel cable strung between 2,050 steel poles embedded 3 feet into the ground, using no concrete and braced laterally with guy wires (90 miles of steel cable) and 14,000 earth anchors. The removal of *Running Fence* started fourteen days after its completion and all materials were given to the ranchers." From press release of the project, 1976.

See nos. 87, 109.

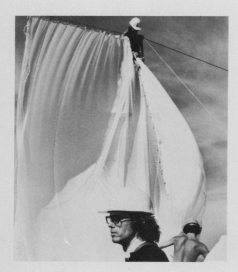

Christo during construction
of *Running Fence,* 1976.

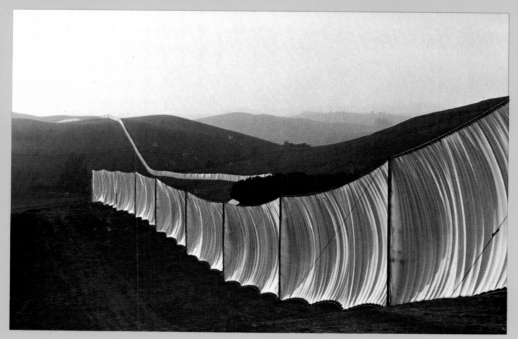

96

97

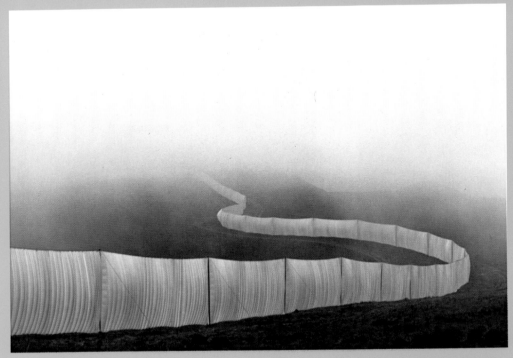

98

126

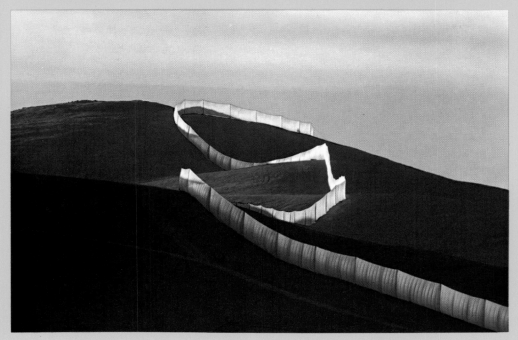

99

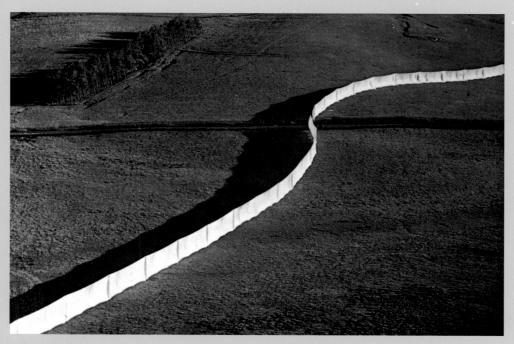

100

## 101. Wrapped Tree, Project

1979
Color lithograph with collage of transparent polyethylene,
fabric, twine, thread, and staples
Size: 22 x 28 in.
Edition: 99 copies (+ 15 A.P. + 15 H.C.)
Paper: Rag, mounted on special cardboard base
Printer: La Poligrafa, Barcelona
Publisher: Ediciones Poligrafa, Barcelona

Christo made this edition to help finance *Running Fence*.

See no. 33.

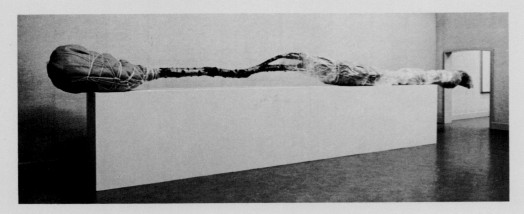

*Wrapped Tree,* 1966.
Stedelijk Van Abbemuseum, Eindhoven

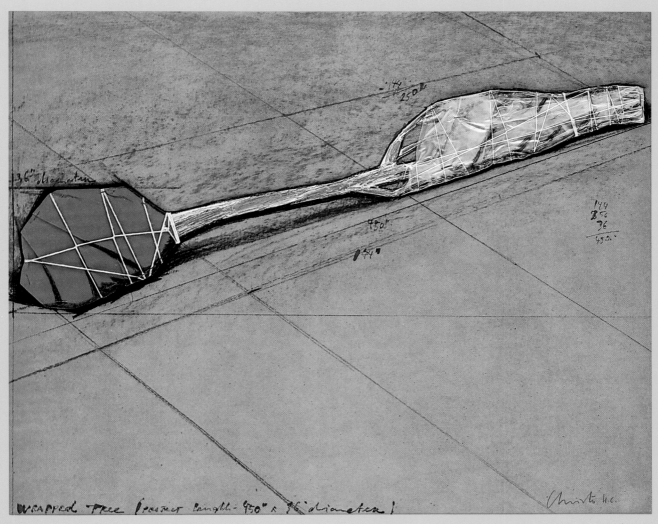

WRAPPED TREE (project length- 950" x 36" diameter)

101

## 102. Orange Store Front, Project

1979
Color lithograph with collage of brown wrapping paper
Size: 14¾ x 10⅝ in.
Edition: 100 copies (+ 18 A.P. + 4 P.P.)
Paper: Arches
Printer: La Poligrafa, Barcelona
Publisher: Ediciones Poligrafa, Barcelona

This edition was included in *Fifteen Years of Poligrafa,*
a portfolio containing the works of eighteen artists.

See nos. 5, 6, 16, 47–49, 93, 104, 105.

## 103. *Chicago* Magazines, Wrapped

1980
Several copies of the newsmagazine *Chicago* wrapped in
transparent polyethylene with cord
Size: 11 x 8⅝ x ¾ in.
Edition: 35 copies (+ 5 A.P.), handmade by Christo
Publisher: Museum of Contemporary Art, Chicago

Christo made this edition as a present to the Museum of
Contemporary Art, Chicago, which he had wrapped in 1969
(see no. 50).

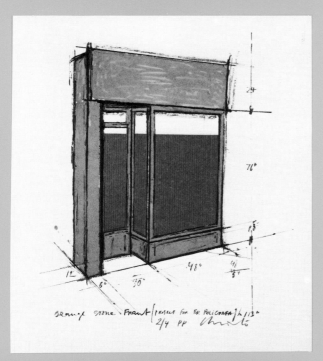

102

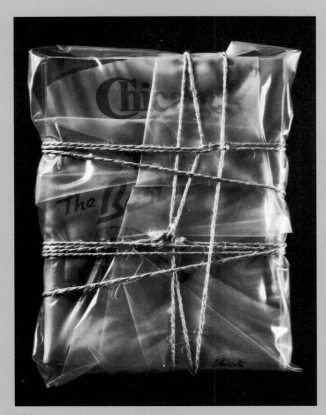

103

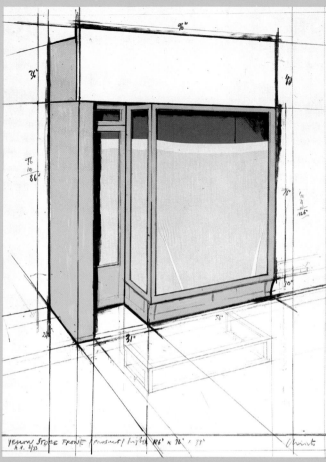

104

### 104. Yellow Store Front, Project

1980
Color lithograph with collage of acetate and cloth
Size: 31¾ x 23½ in.
Edition: 100 copies (+ 23 A.P.)
Paper: Arches, mounted on cardboard
Printer: Landfall Press, Chicago
Publisher: Abrams Original Editions, New York

Christo made this edition to help fund the publication of the
book *Christo: Wrapped Walk Ways* by Ellen Goheen and
Wolfgang Volz, published by Harry N. Abrams, New York.

See nos. 5, 6, 16, 47–49, 93, 102, 105.

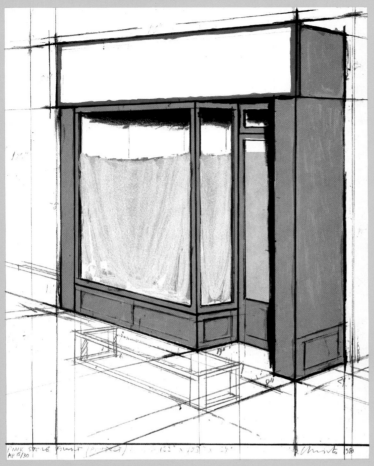

105

## 105. Pink Store Front, Project

1980
Color lithograph with collage of brown wrapping paper
Size: 22¼ x 18 in.
Edition: 100 copies (+ 30 A.P. + 10 S.P.)
Paper: Arches, mounted on cardboard
Printer: Landfall Press, Chicago
Publisher: Makoto Ohaka, Yoshiaki Tono,
Yoich Yamamoto, and Nantenshi Gallery, Tokyo

This print is part of the portfolio *Marginalia,* subtitled
*Homage to Shimizu,* which also contains works by Sam
Francis, Jasper Johns, Claes Oldenburg, and Jean Tinguely.

See nos. 5, 6, 16, 47–49, 93, 102, 104.

## 106. Two Lower Manhattan Wrapped Buildings, Project for New York

1980
Color lithograph with collage of fabric, thread, and city map
Size: 27¾ x 21⅝ in.
Edition: 99 copies (+ 10 A.P. + XV H.C.)
Paper: White board, mounted on cardboard
Photographer: Raymond de Seynes
Printer: La Poligrafa, Barcelona
Publisher: Ediciones Poligrafa, Barcelona

Christo's tight work schedule caused a delay of six years in the completion of this edition, which Poligrafa had paid for and planned to publish in 1974 when Christo needed funds for *Running Fence*.

See nos. 14, 61, 118, 127.

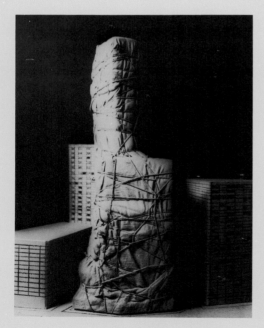

Scale model of *Lower Manhattan Wrapped Building, Project for New York,* 1964—66.

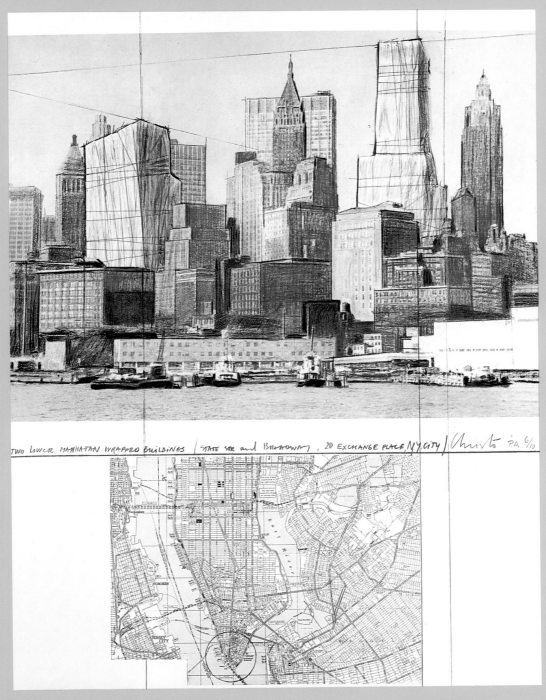

TWO LOWER MANHATAN WRAPPED BUILDINGS ( STATE ST. and BROADWAY , 20 EXCHANGE PLACE, N.Y. CITY ) Christo P.A. 6/10

106

## 107. Puerta de Alcalá, Wrapped, Project for Madrid

1981
Color lithograph with collage of fabric, thread, city map, and photograph
Size: 27⅞ x 21⅝ in.
Edition: 99 copies (+ 10 A.P. + 10 H.C. + XV H.C.)
Paper: White board, mounted on cardboard
Photographer: Wolfgang Volz
Printer: La Poligrafa, Barcelona
Publisher: Ediciones Poligrafa, Barcelona

In 1975 Christo was considering three possibilities for projects in Spain: the Puerta de Alcalá, Madrid, and the monument to Cristóbal Colón and the Fontana de Jujol at Plaza de España, both in Barcelona. Christo chose to try for permission to wrap the monument to Christopher Columbus (see no. 91).

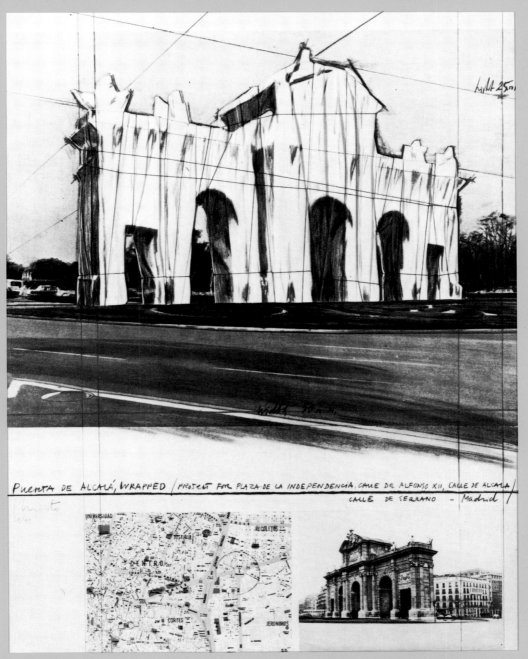

Puerta de Alcalá, Wrapped (Project for Plaza de la Independencia, Calle de Alfonso XII, Calle de Alcalá / Calle de Serrano – Madrid)

107

## 108. Package on Handtruck, Project

1981
Color lithograph with collage of brown canvas,
twine, and staples
Size: 28 x 22¼ in.
Edition: 100 copies (+ 20 A.P. + XX S.P.)
Paper: White museum board, mounted on cardboard
Printer: Landfall Press, Chicago
Publisher: Abrams Original Editions, New York

Christo made several wrapped objects on wheels, including
*Package on Wheelbarrow, Wrapped Motorcycle, Wrapped
Volkswagen* (no longer in existence), *Package on Carrozza*
(see no. 112), and *Wrapped Volvo* (see no. 113).

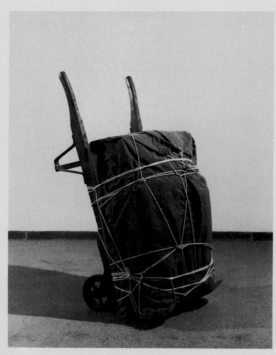

*Package on Handtruck,* 1973.
Whitney Museum of American Art, New York

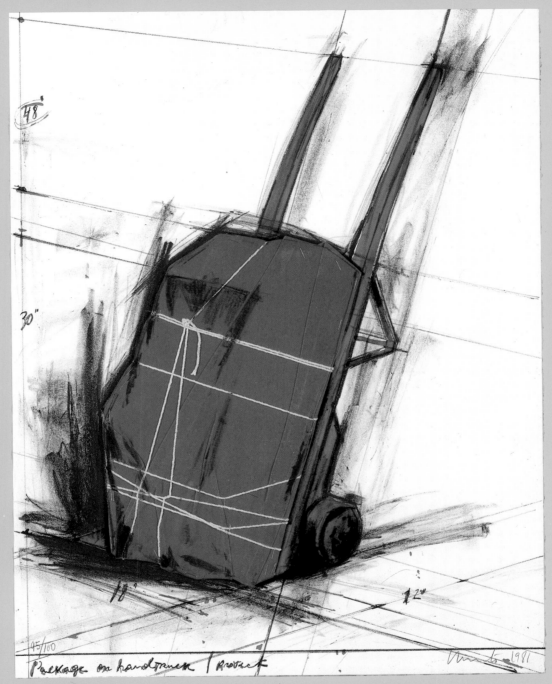

48'

30"

18"

12"

95/100

Package on handtruck / Project                    Christo 1981

108

## 109. Running Fence,
## Sonoma and Marin Counties, California, 1972–76

1982
Color screenprint
Size: 21⅞ x 30 in.
Edition: 300 copies (+ 30 A.P.),
signed by Christo and Wolfgang Volz
Photographer: Wolfgang Volz
Printer: Hans-Peter Haas, Stuttgart
Publisher: City of Kiel, West Germany

This print was published to celebrate the one hundredth
anniversary of Kiel Week, a sailing regatta on the Baltic Sea.
It was included in a portfolio with prints by Horst Antes,
Rudolf Hausner, and Paul Wunderlich.

See nos. 96–100 for project description.
See also no. 87.

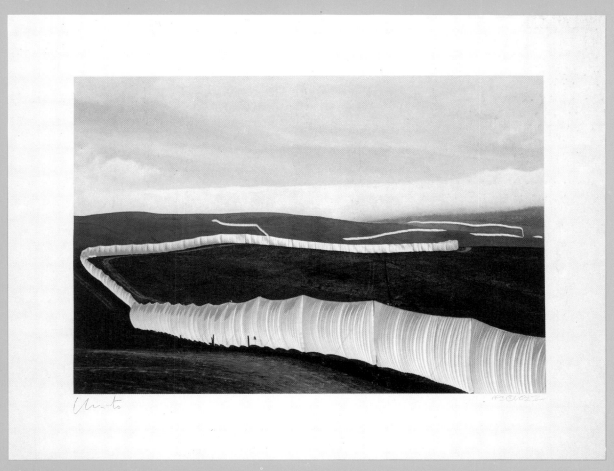

109

## 110. Wrapped Floors,
## Project for Haus Lange Museum, Krefeld

1983
Color lithograph with collage of brown wrapping paper,
hand painted cloth, and staples
Size: 22⅜ x 28⅜ in.
Edition: 100 copies (+ XXV Roman numerals + 20 A.P.)
Paper: Arches Cover White, mounted on cardboard
Printer: Landfall Press, Chicago
Publisher: Edition Schellmann & Klüser, Munich/New York

This print refers to the exhibition *Wrapped Floors, Wrapped
Walk Ways,* installed in 1971 at Haus Lange, part of the Kaiser
Wilhelm Museum, Krefeld, West Germany. This building,
designed by Mies van der Rohe in 1928, demonstrates an
exceptional integration of interior and exterior environments.
In his project Christo separated the inside from the outside
by blocking the windows with a brown-paper covering. He
covered the floors of the ground story with a gray cotton
drop cloth. Outside, the hundred-yard-long walkway was
covered with a straw-colored woven polypropylene.

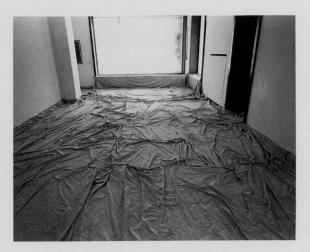

*Wrapped Floors,* Haus Lange Museum, Krefeld, 1971.

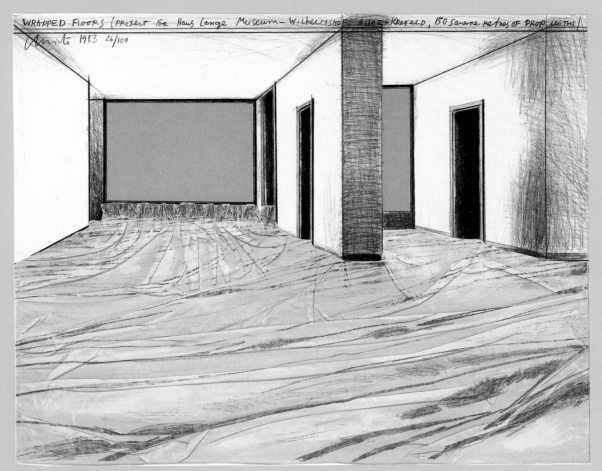

WRAPPED FLOORS (PROJECT FOR Haus Lange Museum - Wilhelmshof Allee - Krefeld, 150 square metres of DROP cloths)
Christo 1983 26/100

110

143

## 111. Wrapped Walk Ways,
## Project for St. Stephen's Green Park, Dublin

1983
Color lithograph with collage of white cloth
Size: 28 x 44⅛ in.
Edition: 100 copies (+ XXV Roman numerals + 20 A.P.)
Paper: Arches Cover White, mounted on cardboard
Photographer: Wolfgang Volz
Printer: Landfall Press, Chicago
Publisher: Edition Schellmann & Klüser, Munich/New York

While visiting Burma, Thailand, and Cambodia, Christo became aware of the ceremonial use of gardens. He noticed the way the inhabitants of these countries were attuned to their surroundings, especially to the surfaces upon which they walked.

In 1970 Christo proposed a first *Wrapped Walk Ways* project for Sonsbeek Park, Arnhem, in the Netherlands and at the same time for Ueno Park, Tokyo, Japan. One of the most intriguing factors of this project was that the two parts were to be installed simultaneously, 6000 miles apart.

In 1971 Christo accomplished a smaller version: *Wrapped Floors, Wrapped Walk Ways* at Haus Lange, part of the Kaiser Wilhelm Museum in Krefeld, West Germany (see no. 110).

In 1976 Christo made another attempt to do a large-scale *Wrapped Walk Ways,* this time in Dublin, Ireland, in St. Stephen's Green Park, a small park in the city center. Christo was invited to ROSC, an international art exhibition held every four years. Instead of lending a piece he offered the project to the city, but again permission was denied.

Finally Christo realized *Wrapped Walk Ways, Loose Park, Kansas City, Missouri, 1977–78,* between October 2 and 16, 1978. The project consisted of 136,268 square feet of saffron-colored nylon cloth covering 104,836 square feet of formal garden walkways and jogging paths.

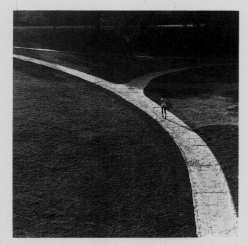

*Wrapped Walk Ways,* Loose Park,
Kansas City, Missouri, 1978.

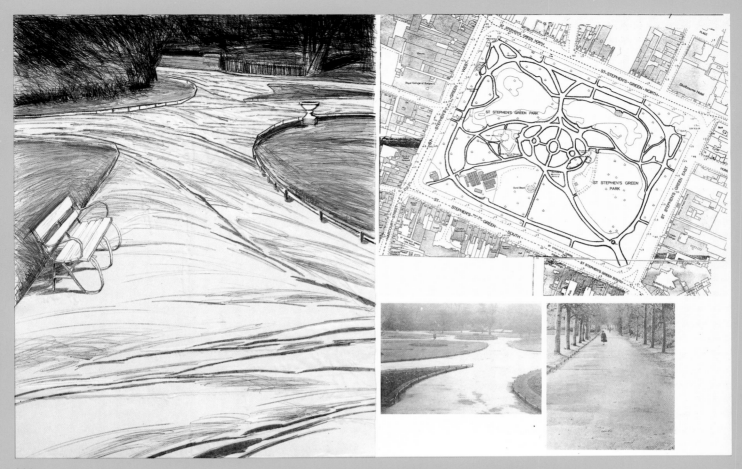

111

## 112. Package on Carrozza, Project for A. Berlingieri, Taranto, Italy

1984
Lithograph (b/w) with collage of fabric and thread
Size: 22¼ x 28 in.
Edition: 100 copies (+ XX Roman numerals + 20 A.P.)
Paper: Arches Cover White, mounted on museum board
Printer: Landfall Press, Chicago
Publisher: Christo and Edition Schellmann, Munich/New York

In 1971 Christo wrapped a nineteenth-century carriage in the palazzo of Annibale Berlingieri, near Taranto. Berlingieri's purchase of *Wrapped Carrozza* helped to finance *Valley Curtain*.

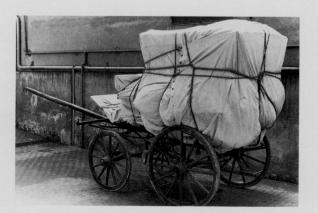

*Wrapped Carrozza,* 1971.

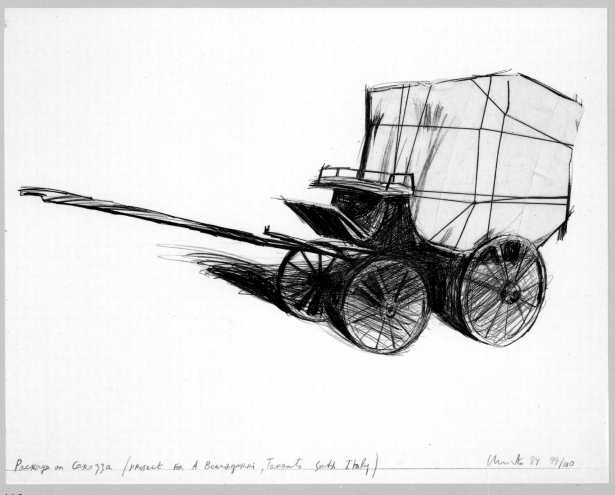

Package on Carozza (project for A. Beauxgorri, Taranto South Italy) _____ Christo 84 99/100

112

## 113. Wrapped Automobile,
## Project for Volvo 122 S Sport Sedan

1984
Lithograph with collage of fabric and twine
Size: 22¼ x 28 in.
Edition: 100 copies (+ XX Roman numerals + 20 A.P.)
Paper: Rives BFK, mounted on museum board
Printer: Landfall Press, Chicago
Publisher: Christo and Edition Schellmann, Munich/New York

In 1981, when Serge de Bloe of Brussels was purchasing a
new car, he invited Christo to wrap his old Volvo.
Christo had already wrapped a Renault 4 CV in Cologne in
1961 and a Volkswagen beetle in Düsseldorf in 1963.

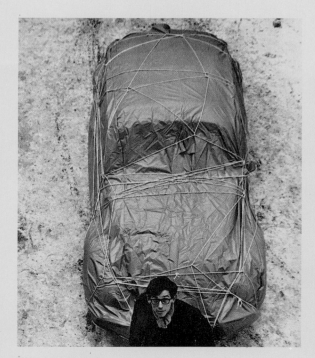

*Wrapped Volkswagen,* 1963.
(no longer in existence)

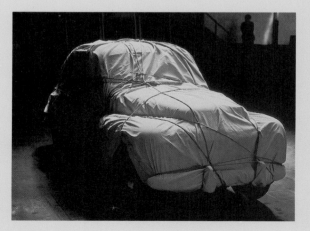

*Wrapped Volvo,* 1981.

148

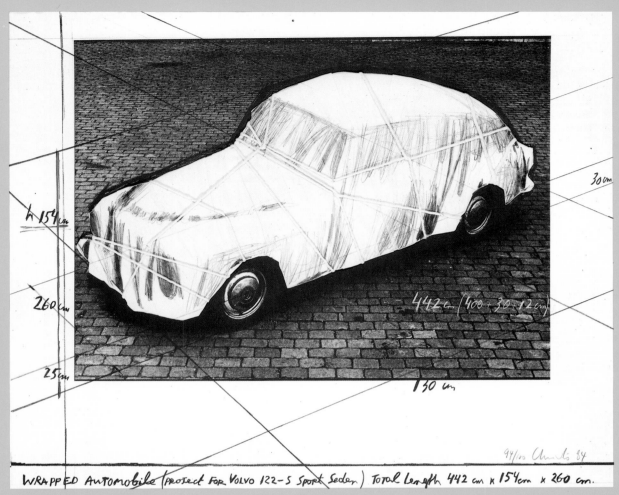

h 154 cm

260 cm

25 cm

30 cm

442 cm (400 + 30 + 12 cm)

130 cm

94/100 Christo 84

WRAPPED Automobile (Project for Volvo 122-S Sport Sedan) Total Length 442 cm x 154cm x 260 cm.

113

## 114 – 117. Surrounded Islands,
## Biscayne Bay, Greater Miami, Florida, 1980 – 83

1984
Portfolio with 4 dye-transfer color photographs, mounted on
rag paper, and sample of fabric used in the project
Size: 19½ x 23½ in.
Edition: 100 copies (+ 15 A.P. + 10 H.C. + 2 P.P.),
signed by Christo and Wolfgang Volz
Photographer: Wolfgang Volz
Printer: Creative Colour GmbH, Hamburg
Publisher: Hugh L. Levin Associates, New York

Christo donated the rights of this edition to his friend and
photographer Wolfgang Volz, who has been working with him
since 1970.

"In Biscayne Bay, located between the City of Miami, North
Miami, and Miami Beach, eleven islands will be surrounded
with 6 million square feet of pink woven polypropylene fabric
covering the surface of the water, floating and extending out
200 feet from the island into the bay. The fabric will be sewn
into 70 patterns to follow the contours of the islands.
As with my previous projects, *Surrounded Islands* will be
entirely financed by me, through the sale of my preparatory
drawings, collages, studies, and early works.

"For a period of two weeks, *Surrounded Islands* will extend
several miles altogether and will be seen, approached and
enjoyed from the causeways, the land, the water and the air.
The luminous pink color of the shiny fabric will be in harmony
with the tropical vegetation of the uninhabited verdant
islands, the light of Miami sky and the colors of the waters
of the shallow Biscayne Bay.

"*Surrounded Islands* underlines the various elements and
ways in which the people of Miami live, between land and
water."
From press release of the project, 1983.

See nos. 122, 132.

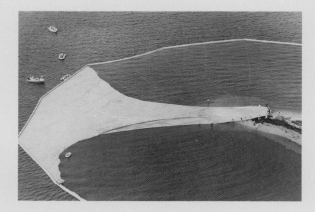

*Surrounded Islands* during construction, 1983.

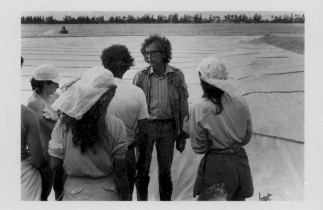

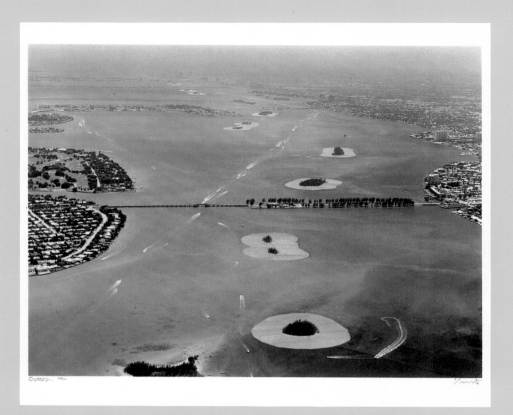

114

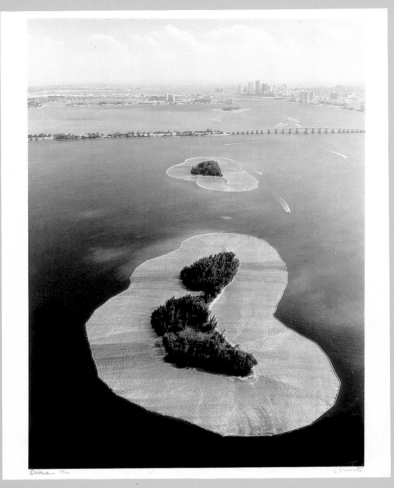

115

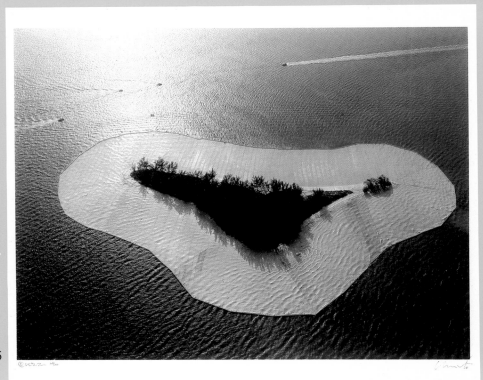

116

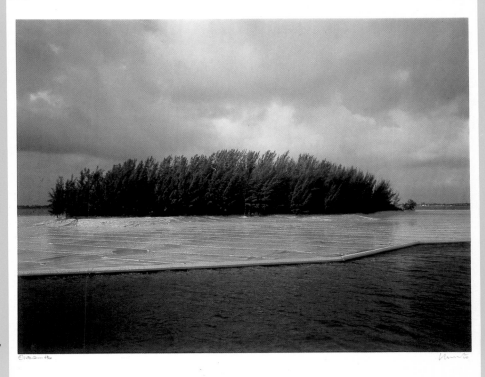

117

118. Lower Manhattan Wrapped Building,
Project for 2 Broadway, New York

1984
Color lithograph with collage of fabric, twine, and thread
Size: 28 x 22 in.
Edition: 110 copies (+ XX Roman numerals + 20 A.P.)
Paper: Rives BFK, mounted on museum board
Printer: Landfall Press, Chicago
Publisher: Torsten Lilja, Stockholm

This edition was sold to help finance *The Pont-Neuf, Wrapped,*
Paris.

See nos. 14, 61, 106, 127.

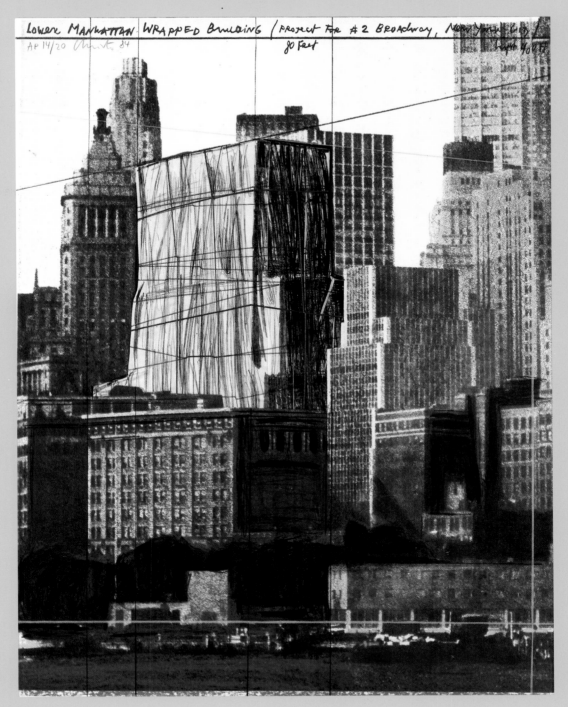

Lower Manhattan Wrapped Building (Project for #2 Broadway, New York City)
90 Feet

118

## 119. Wrapped Telephone, Project for L. M. Ericsson Model

1985
Color lithograph with collage of fabric, twine, and photograph
Size: 28 x 22 in.
Edition: 100 copies (+ XX Roman numerals + 35 A.P.)
Paper: Arches Cover White, mounted on museum board
Photographers: Eeva – Inkeri
Printer: Landfall Press, Chicago
Publisher: L. M. Ericsson, New Jersey

This print, as well as print no. 120, was commissioned by the electrical corporation L. M. Ericsson.

*Wrapped Telephone,* 1963.

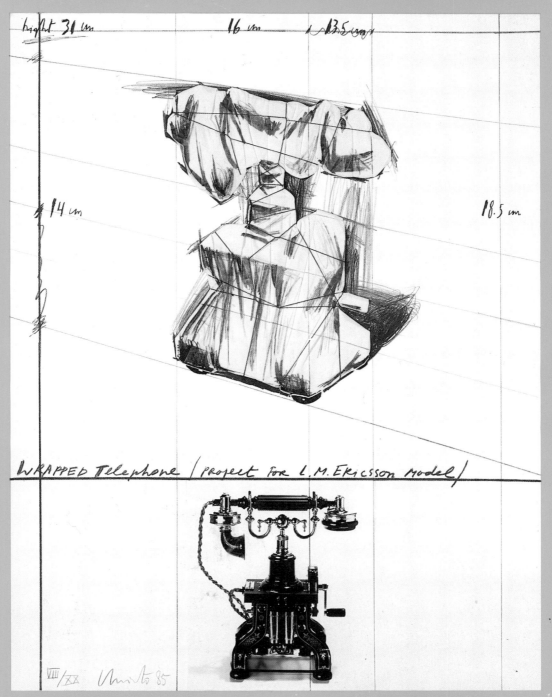

height 31 cm       16 cm      13.5 cm

14 cm                   18.5 cm

WRAPPED Telephone /PROJECT for L.M.ERICSSON Model/

VIII/XX   Christo 85

119

## 120. Ericsson Display Monitor Unit 3111, Wrapped, Project for Personal Computer

1985
Color lithograph with collage of transparent polyethylene, twine, and color photograph
Size: 28 x 22½ in.
Edition: 100 copies (+ XX Roman numerals + 35 A.P.)
Paper: Arches Cover White, mounted on museum board
Photographers: Eeva – Inkeri
Printer: Landfall Press, Chicago
Publisher: L. M. Ericsson, New Jersey

See no. 119.

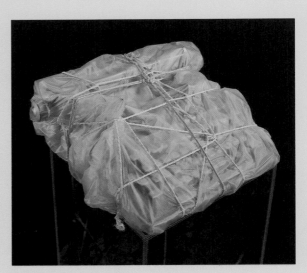

*Wrapped Typewriter,* 1969.

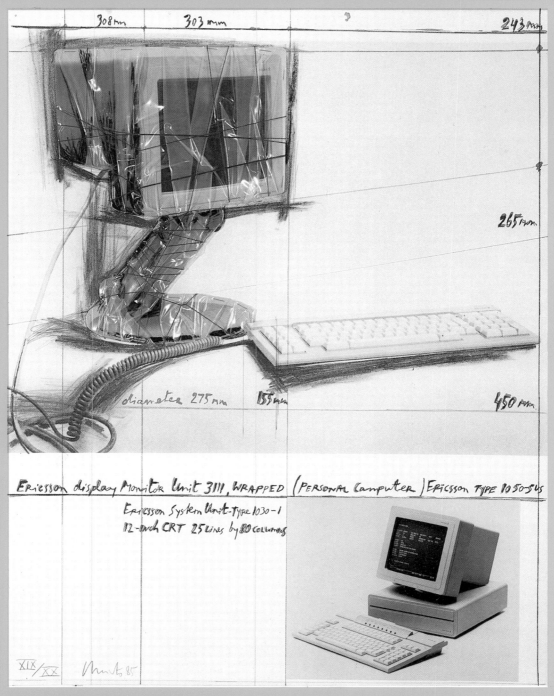

Ericsson display Monitor Unit 3111, WRAPPED (PERSONAL Computer) Ericsson Type 1050-545

Ericsson System Unit Type 1030-1
12-inch CRT 25 lines by 80 columns

308 mm    303 mm    243 mm

265 mm

diameter 275 mm    155 mm    450 mm

XIX/XX    Christo 85

120

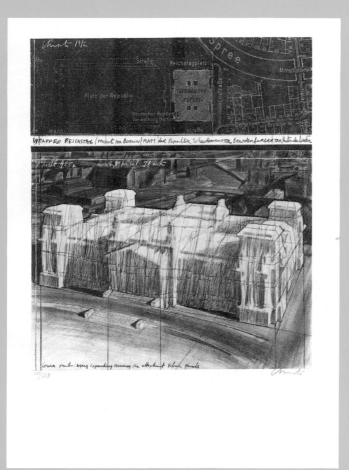

121

## 121. Wrapped Reichstag, Project for Berlin

1985
Color offset print
Size: 27½ x 19¾ in.
Edition: 120 copies (+ XX Roman numerals + 30 A.P.)
Paper: White board
Printer: Gerhard Steidl, Göttingen
Publisher: Edition Staeck, Heidelberg

This print is part of the portfolio *Transit,* containing works by twenty-two artists, published to celebrate the twentieth anniversary of Edition Staeck, Heidelberg.

Since 1972 Christo has been trying to obtain permission to wrap the Reichstag building in West Berlin.

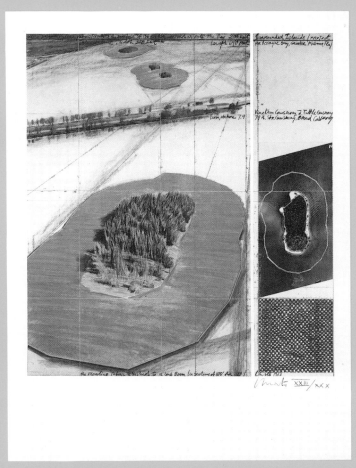

122

## 122. Surrounded Islands,
## Project for Biscayne Bay, Greater Miami, Florida

1985
Color offset print with collage of pink woven
polypropylene fabric
Size: 30⅞ x 24 in.
Edition: 100 copies (+ XXX Roman numerals + 30 A.P.)
Paper: Arches
Printer: Jacques London, Paris
Publisher: Fondation Maeght, St. Paul de Vence

This print was published on the occasion of *Surrounded
Islands, 1980 – 83,* an exhibition of documentation at the Fon-
dation Maeght, St. Paul de Vence, France, May – June 1985.
The same print, with additional type and without the collage,
served as a poster for the exhibition.

See nos. 114 – 117 for project description.
See also no. 132.

## 123 – 127. Five Urban Projects

1985
Portfolio with 5 prints:
123. *Ponte S. Angelo, Wrapped, Project for Rome*
Photograph mounted on rag paper, with collotype,
silkscreen, and collage of masking tape
124. *Wrapped Trees, Project for the Avenue des Champs-
Elysées, Paris*
Photograph mounted on rag paper, with collotype,
silkscreen, and collage of transparent polyethylene,
twine, and staples; grease pencil and felt marker
additions
125. *Mein Kölner Dom, Wrapped, Project for Köln*
Color photograph mounted on rag paper, with collotype
and silkscreen
126. *Curtains for La Rotonda, Project for Milan*
Photograph mounted on rag paper, with collotype,
silkscreen, and collage of masking tape and fabric;
pencil additions
127. *Lower Manhattan Wrapped Building, Project for
New York*
Photograph mounted on rag paper, with collotype,
silkscreen, and collage of fabric and twine; pencil
additions

Size: no. 123: 11 x 14 in.; nos. 124–127: 14 x 11 in.
Edition: 100 copies (+ 20 A.P. + XX A.P. + 5 P.P.)
Paper: 270 g Arches
Photographer: Jeanne-Claude Christo (nos. 124, 126, 127)
Printer: Domberger KG, Stuttgart
Publisher: Edition Schellmann, Munich/New York

No. 123: This was the first bridge Christo had proposed for
wrapping, in 1967. He later considered the Pont Alexandre III,
and finally he wrapped the Pont-Neuf, Paris, in 1985 (see no. 86).
No. 124: See no. 133.
No. 125: In 1980 the Cologne Kunstverein asked fifty-five
international artists to participate in the exhibition *Mein
Kölner Dom – The Cologne Cathedral Seen by Contemporary
Artists.* Christo never planned to wrap Cologne Cathedral but he
contributed this project to the show.
No. 126: While his exhibition of *Valley Curtain, 1970–72*
documentation was in progress at the Rotonda della Besana,
Milan, in 1973, Christo wanted to veil the exterior circular
colonnade of the Rotonda, but the project was turned down.
No. 127: See nos. 14, 61, 106, 118.

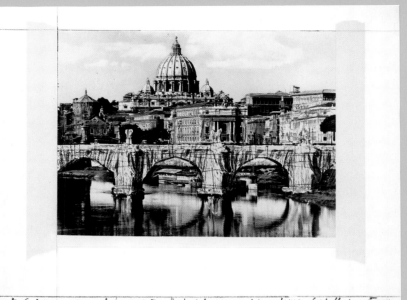

Ponte S. Angelo, wrapped (project for Ponte S. Angelo and Longotevere Castello, Longotevere Vaticano, Longotevere D. Altoviti, Longotevere Tore di Roma)

Christo 82/100

123

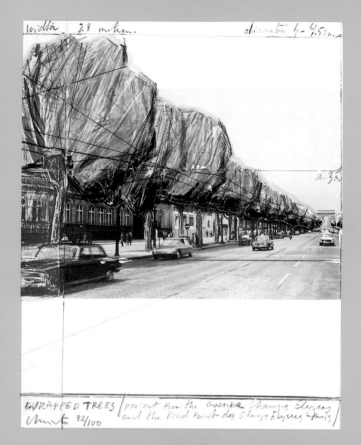

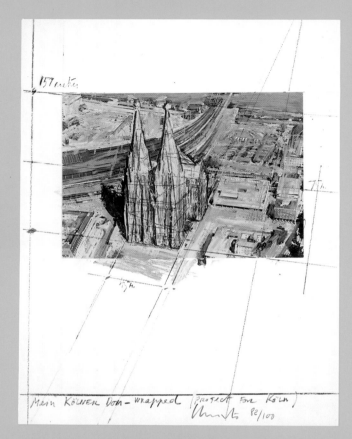

124

125

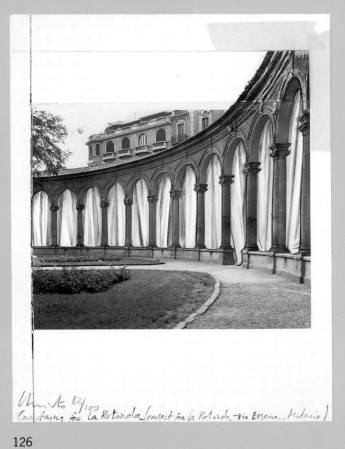

Christo 82/100
Curtains for La Rotonda (Project for La Rotonda – Via Besana, Milano)

126

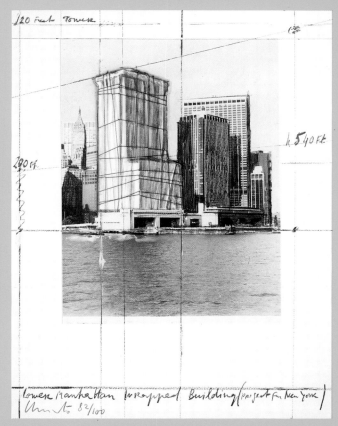

120 Feet Tower
200 Ft
4.540 Ft

Lower Manhattan Wrapped Building (Project for New York)
Christo 82/100

127

<u>128. Wrapped Building,</u>
<u>Project for 1 Times Square, New York</u>

1985
Color lithograph with collage of fabric, thread, transparent
polyethylene, and staples
Size: 28⅛ x 22¼ in.
Edition: 100 copies (+ 25 A.P. + 25 H.C. + 26 "S.P. J.C.")
Paper: Guarro, mounted on cardboard
Printer: La Poligrafa, Barcelona
Publisher: Ediciones Poligrafa, Barcelona

See nos. 38, 39.

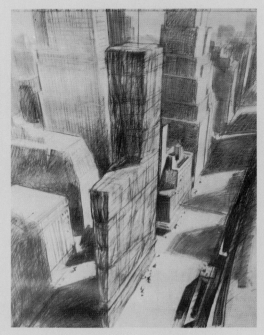

*Wrapped Building, Project for 1 Times Square,*
*New York,* 1968, drawing.

166

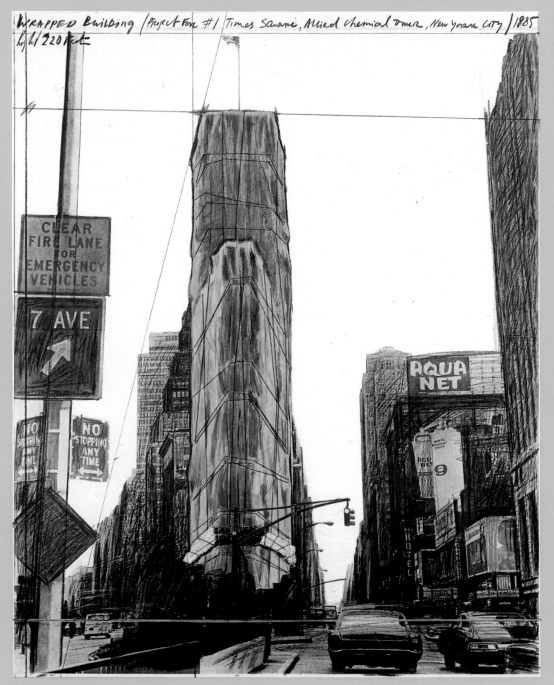

Wrapped Building /Project For #/ Times Square, Allied Chemical Tower, New York City /1985
h/w/ 220 feet

128

167

## 129. Wrapped *New York Times,* June 13, 1985

1985
The *New York Times* newspaper folded and wrapped in
transparent polyethylene with cord and twine
Size: 6¼ x 15¼ x 1½ in.
Edition: 85 copies (+ XIII Roman numerals + 35 A.P.),
handmade by Christo
Publisher: Hugh L. Levin Associates, New York

On June 13, 1985, Christo and his wife, Jeanne-Claude,
celebrated their joint one hundredth birthday — they were
both born on June 13, 1935. This edition was done in honor
of the event.

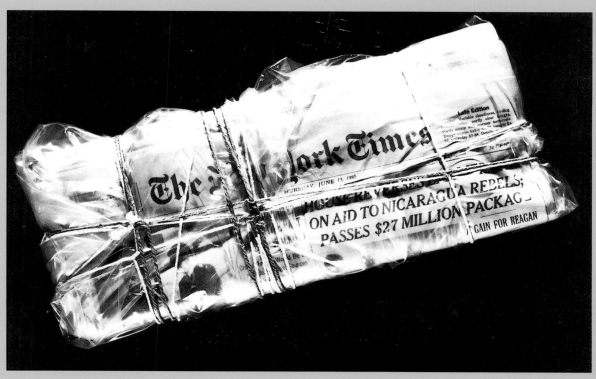

129

## 130. The Mastaba, Project for Kunstverein Köln

1986
Photograph mounted on rag paper, with color silkscreen
and collotype
Size: 34½ x 28 in.
Edition: 200 copies (+ 50 A.P.)
Paper: 350 g Fabriano
Photographer: Wolfgang Volz
Printer: Domberger KG, Stuttgart
Publisher: Kölnischer Kunstverein, Köln

This print was sold by the Cologne Kunstverein to its
members; an oil drum from the original installation came with
the print.

The mastaba, built out of 1,000 oil barrels, was made for the
exhibition *The 60's – Cologne's Emergence as Art Metropolis
– From Happening to Art Market* at the Cologne Kunstverein
in 1986. See no. 89.

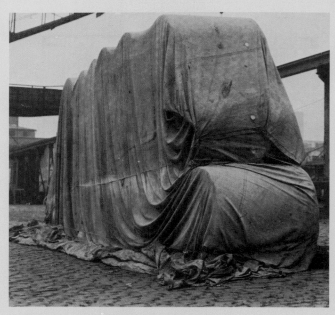

*Dockside Package,* Cologne, 1961.

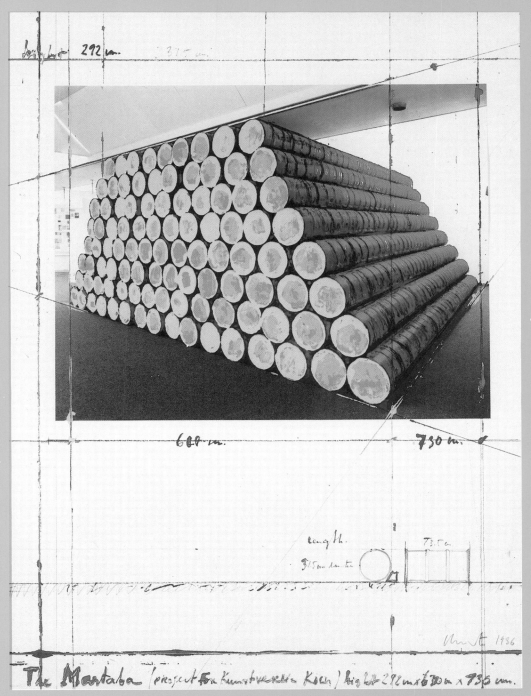

height 292 cm.    315 cm.

600 m.              730 m.

length.
315 mm. diameter        73.5 cm.

Christo 1986

The Mastaba (project for Kunstverein Köln) height 292 m × 600 m × 730 cm.

130

171

## 131. 5,600 Cubic Meter Package, Kassel, 1968

1986–87
Silkscreen and collotype, with collage of 3 photographs (b/w),
transparent polyethylene, and thread; felt marker additions
Size: 31½ x 23⅝ in.
Edition: 90 copies (+ XXX Roman numerals + 30 A.P. + 5 P.P.)
Paper: 350 g Fabriano
Photographer: Klaus Baum
Printer: Domberger KG, Stuttgart
Publisher: Galerie Bernd Klüser, Munich, and
Edition Schellmann, Munich/New York

This print was published as part of the portfolio *for Joseph
Beuys,* with works by thirty international artists.

See no. 9 for project description.
See also nos. 10–12, 15.

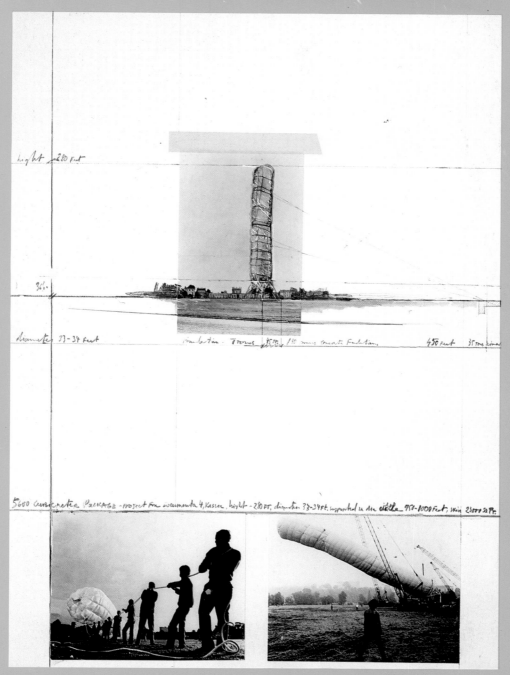

131

## 132. Surrounded Islands,
## Project for Biscayne Bay, Greater Miami, Florida

1987
Two-part print. Part 1 (left): photograph mounted on rag
paper, with collotype, color silkscreen, and collage of masking
tape; part 2 (right): collotype and silkscreen with collage of
map, pink woven polypropylene fabric, and masking tape
Size: 15 x 15¾ in. each
Edition: 125 copies (+ 30 A.P. + XIV A.P. + 5 P.P.)
Paper: 350 g Fabriano
Photographer: Wolfgang Volz
Printer: Domberger KG, Stuttgart
Publisher: Edition Schellmann, Munich/New York

See nos. 114–117 for project description.
See also no. 122.

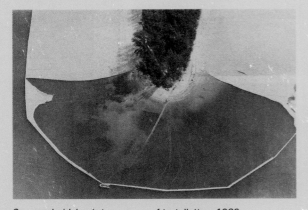

*Surrounded Islands* in process of installation, 1983.

174

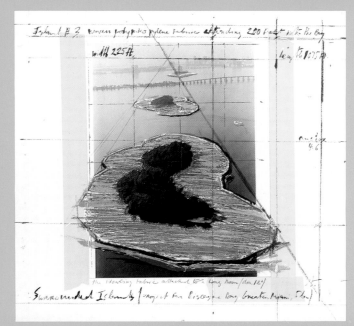

Island # 3 woven polypropylene fabric extending 200 feet into the Bay

width 225 ft.                                               length 1075 ft.

one side 46

The floating fabric attached to long boom (dia. 12")

*Surrounded Islands* (project for Biscayne Bay, Greater Miami, Fla.)

132

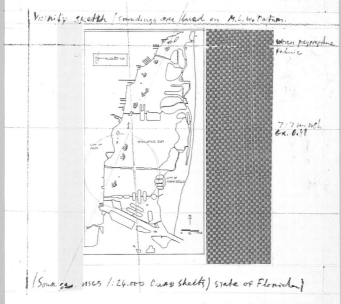

Vicinity sketch (soundings are based on M.L.W. datum.

woven polypropylene fabric

7 x 7 per inch Ex. 0.98

(Source: USGS 1:24.000 Quad Sheets) State of Florida)

## 133. Wrapped Trees,
## Project for the Avenue des Champs-Elysées, Paris

1987
Color lithograph with collage of transparent polyethylene, thread, and staples; felt marker additions
Size: 28 x 22¼ in.
Edition: 200 copies (+ XL Roman numerals + 45 A.P.)
Paper: Arches Cover White, mounted on museum board
Printer: Landfall Press, Chicago
Publisher: Torsten Lilja, Stockholm

This edition was made to help fund *The Pont-Neuf, Wrapped, Paris.*

The first collages for this project were done in 1968, at the same time that Christo started to negotiate permission for wrapping the 330 trees bordering the Avenue des Champs-Elysées and the Rond Point. A professional arborist studied the possible effects of wrapping the trees and stated that the woven fabric would protect the plants during winter, citing the Japanese practice as an example. While working in Australia on *Wrapped Coast,* Christo was told that Paris had decided instead to decorate the trees with electric Christmas lights.

See no. 124.

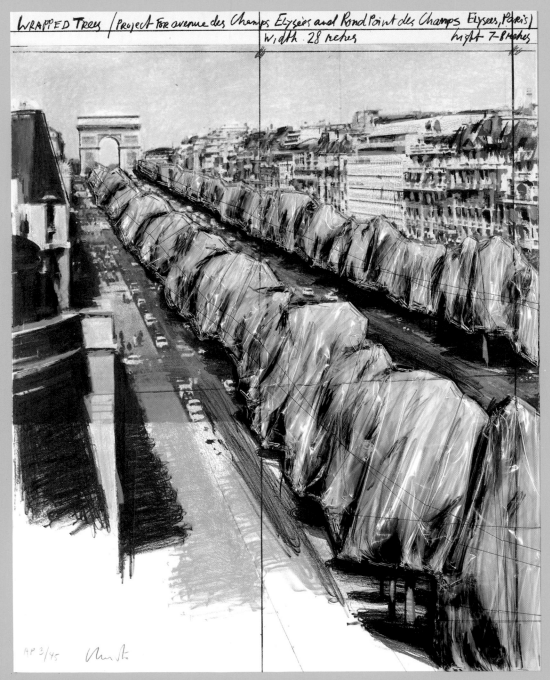

133

# Key to the Catalogue

Sequence: Prints and objects are arranged in chronological order by date of publication.

Dimensions: Height precedes width precedes depth; sizes are given in inches. Dimensions for prints indicate the size of the paper; dimensions for objects indicate the overall size.

Signatures and Marks: All prints and objects published in this book, unless otherwise noted, are signed and numbered, usually in pencil on the front. They are numbered in Arabic numerals unless otherwise noted. Many prints are also dated.

Proofs: All proofs are of quality equal to the edition. Abbreviations used in this catalogue are as follows:

A.P. Artist's Proofs, indicated as A.P. or E.A. (Epreuve d'Artiste). An edition of 15 A.P. is numbered A.P. 1/15 through A.P. 15/15, or A.P. 1 through A.P. 15, or just A.P.

P.P. Printer's Proofs, numbered as P.P. 1, etc.

H.C. Hors de Commerce prints, numbered as H.C. 1, etc. They are often produced for collaborators.

S.P. Special Proofs, numbered as S.P. 1, etc. In some cases S.P.J.C. (Special Proof for Jeanne-Claude Christo) appears.

Additional proofs were sometimes made in very small numbers (1–3), but are not mentioned in this catalogue:

Exhibition Proofs, numbered as E.P. 1, etc. These are prints produced for exhibition purposes.

Copyright Proofs, numbered as C.P. 1, etc. These are prints for the U.S. Copyright Office, Washington, D.C.

Trial Proofs, numbered as T.P. 1, etc., or Working Proof 1, etc. These are prints pulled during the proofing process to document technical changes before the edition is run.

Bon à tirer print (ready for the press), indicated as B.A.T. This is the last Trial Proof and is used as a model for the edition.

Printing Techniques: Offset in most cases means offset reproduction from a photograph or drawing. Silkscreen and screenprint are used as synonyms. In the works that include collage, the print is often die-cut to accommodate the fabric, polyethylene, acetate, wrapping paper, or other collage material. The appearance of (b/w) in the description of a work indicates black and white.

# Concordance

The catalogue raisonné numbers of *Christo Editions 1964–82,* by Per Hovdenakk and Jörg Schellmann, correspond as follows to the numbers of this book.

| Schellmann/ Benecke: | Hovdenakk/ Schellmann: | Schellmann/ Benecke: | Hovdenakk/ Schellmann: |
|---|---|---|---|
| 1 | 1 | 64–67 | 37 |
| 2 | 2 | 68 | 38 |
| 3 | 3 | 69 | 44 |
| 4 | 4 | 70–73 | 41 |
| 5 | 5 | 74 | 39 |
| 6 | 6 | 75 | 40 |
| 7 | 7 | 76 | 42 |
| 8 | 8 | 77–84 | 43a–h |
| 9 | 9 | 85 | 45 |
| 10 | 10 | 86 | 46 |
| 11 | 11 | 87 | 47 |
| 12–22 | 12a–k | 88 | 48 |
| 23 | 14 | 89 | 49 |
| 24 | 15 | 90 | 50 |
| 25 | 13 | 91 | 51 |
| 26 | 16 | 92 | — |
| 27 | 17 | 93 | 52 |
| 28 | 18 | 94 | 53 |
| 29 | 19 | 95 | 54 |
| 30 | 20 | 96–100 | 55 |
| 31 | 21 | 101 | 56 |
| 32 | 22 | 102 | 58 |
| 33 | 23 | 103 | 57 |
| 34 | 24 | 104 | 59 |
| 35–39 | 25a–e | 105 | 60 |
| 40–42 | 26a–c | 106 | 61 |
| 43–46 | 27a–d | 107 | 62 |
| 47–49 | 28a–c | 108 | 63 |
| 50 | 29 | 109 | 64 |
| 51 | 30 | 110 | 65 |
| 52–55 | 31a–e | 111 | 66 |
| 56–58 | 32a–f | | |
| 59 | 33A | | |
| 60 | 33B | | |
| 61 | 34 | | |
| 62 | 35 | | |
| 63 | 36 | | |

The works numbered 112–133 are new and did not appear in the previous book.

# Chronology

| 1935 | Christo Javacheff born June 13 in Gabrovo, Bulgaria. |
| 1952–56 | Studies at the Fine Arts Academy, Sofia. |
| 1956 | Work-study at the Burian Theater, Prague. |
| 1957 | Studies for one semester at the Vienna Fine Arts Academy. |
| 1958 | Arrives in Paris. Meets Jeanne-Claude de Guillebon. *Packages* and *Wrapped Objects*. |
| 1961 | Project for the *Packaging of a Public Building*. *Stacked Oil Barrels* and *Dockside Packages* in Cologne Harbor. |
| 1962 | *Iron Curtain – Wall of Oil Barrels*, blocking the rue Visconti, Paris. *Stacked Oil Barrels* in Gentilly, near Paris. *Wrapping a Girl*, London. |
| 1963 | *Showcases*. |
| 1964 | Establishes permanent residence in New York. *Store Fronts*. |
| 1966 | *Air Package* and *Wrapped Tree*, Stedelijk Van Abbemuseum, Eindhoven, Netherlands. *42,390 Cubic Feet Empaquetage*, Walker Art Center, Minneapolis, and Minneapolis School of Art. |
| 1968 | *Packed Fountain* and *Packed Tower*, Spoleto, Italy. *Packed Kunsthalle Bern*. *5,600 Cubic Meter Package* and *Corridor Store Front*, Documenta 4, Kassel, West Germany. *1,240 Oil Barrels Mastaba* and *Two Tons of Stacked Hay*, Institute of Contemporary Art, University of Pennsylvania, Philadelphia. |
| 1969 | *Packed Museum of Contemporary Art* and *Wrapped Floor*, Museum of Contemporary Art, Chicago. *Wrapped Coast, One Million Square Feet*, Little Bay, Sydney, Australia. Project for *Houston Mastaba*, Houston, Texas. Project for *Closed Highway* across the United States. |
| 1970 | *Wrapped Monument to Vittorio Emanuele* and *Wrapped Monument to Leonardo da Vinci*, Milan. |
| 1972 | *Wrapped Reichstag, Project for Berlin*, in progress. *Valley Curtain*, Rifle, Colorado, 1970–72. |
| 1974 | *The Wall, Wrapped Roman Wall*, Via V. Veneto and Villa Borghese, Rome. *Ocean Front*, Newport, Rhode Island. |
| 1976 | *Running Fence*, Sonoma and Marin Counties, California, 1972–76. |
| 1978 | *Wrapped Walk Ways*, Loose Park, Kansas City, Missouri, 1977–78. |
| 1979 | *The Mastaba of Abu Dhabi, Project for the United Arab Emirates*, in progress. |
| 1980 | *The Gates, Project for Central Park, New York City*, in progress. |
| 1983 | *Surrounded Islands*, Biscayne Bay, Greater Miami, Florida, 1980–83. |
| 1985 | *The Umbrellas, Project for Japan and Western USA*, in progress. *The Pont-Neuf, Wrapped*, Paris, 1975–85. |

# Index of Titles

## Photography Credits

Klaus Baum: p. 30
Serge de Bloe: p. 148
Ferdinand Boesch: pp. 24, 112
Geoffrey Clements: p. 138
Norbert Denkel: p. 118
Eeva — Inkeri: pp. 114, 156
Farbwerke Hoechst AG: p. 30
Ugo Mulas: p. 134
Guido le Noci: p. 146
Ad Petersen: p. 128
Allen Schumeister: p. 158
Raymond de Seynes: p. 42
Harry Shunk: pp. 54, 55, 62, 84, 85, 88, 96, 98, 99, 166
Wolfgang Volz: pp. 2, 4, 5, 6, 7, 108, 109, 110, 124, 142, 144, 150, 174
Stefan Wewerka: p. 170
Charles Wilp: p. 148